© Victor Burgin

First published 1986
**Basil Blackwell Limited**
108 Cowley Road, Oxford OX4 1JF, and in association with the
**Institute of Contemporary Arts**
12 Carlton house Terrace, London SW1Y 5AH

Basil Blackwell Inc.
432 Park Avenue South, Suite 1505,
New York, NY 10016, USA

Designed by Robert Carter
Typeset by Artworkers, London
Printed for the Journeyman Press, London N8
by Balding + Mansell Limited, Wisbech, England

**ISBN 0 631 15235 0**

Institute of Contemporary Arts
Exhibitions Director: Declan McGonagle
Associate Exhibitions Director: Andrea Schlieker
Gallery Manager: Stephen White
Gallery Assistant/Publications: James Peto
Director: Bill McAlister

The ICA is an independant educational charity and while gratefully acknowledging the financial assistance of the Arts Council of Great Britain, the British Film Institute and the Greater London Council, is primarily reliant on its box office income, membership and donations.

# Between

Also published in association with
**Kettle's Yard, University of Cambridge**
**Massachusetts Institute of Technology, Committee on the Visual Arts**
**The Orchard Gallery, Derry, N. Ireland**
**The Renaissance Society at the University of Chicago**

# VICTOR BURGIN

# *Between*

Basil Blackwell • Institute of Contemporary Arts

SIR JOSHUA REYNOLDS, GARRICK BETWEEN COMEDY AND TRAGEDY, 1761. PRIVATE COLLECTION

*Very rarely does the complexity of human character, driven hither and thither by dynamic forces, submit to a choice between simple alternatives, as our antiquated morality would have us believe.*

**SIGMUND FREUD, THE INTERPRETATION OF DREAMS**

*His language, so familiar and so foreign, will always be for me an acquired speech. I have not made or accepted its words. My voice holds them at bay. My soul frets in the shadow of his language.*

**JAMES JOYCE, PORTRAIT OF THE ARTIST AS A YOUNG MAN**

*(is not to be modern to know clearly what cannot be started over again?)*

**ROLAND BARTHES, 'FROM WORK TO TEXT'**

MY DECISION TO BASE MY WORK IN CONTEMPORARY CULTURAL theory, rather than in traditional aesthetics, has resulted in work whose precise 'location' is uncertain, 'between': between gallery and book; between 'visual art' and 'theory'; between 'image' and 'narrative' - 'work' providing *work* between reader and text. The works reproduced here, made between 1975 and 1985, are connected by extracts from contemporaneous talks, interviews, letters, and so on, in which I discuss the works. I am grateful to my questioners, both those whose names appear, and those who must remain anonymous. I have not included extracts from my theoretical writings, as these are available elsewhere, but they are an integral part of the project to which my work *here* contributes.

*die Idee einer anderer Lokalität*, the idea of another locality, another space, another scene, *the between perception and consciousness.*

**JACQUES LACAN, THE FOUR FUNDAMENTAL CONCEPTS OF PSYCHOANALYSIS**

*Twentieth-century art has done a very, very good job. What job? To open people's eyes, to open people's ears. What better things could have been done? We must turn our attention now I think to other things, and those things are social.*

**JOHN CAGE, BBC INTERVIEW**

NONE OF US FEND FOR OURSELVES, WE RELY UPON EACH OTHER. The expression of this mutual interdependence is a society. Anyone who lives in a society, enjoying its benefits and subject to its restrictions, is 'politically committed' — committed to specific forms of social organisation within which he or she occupies objective positions.

**OVERLEAF: THINK ABOUT IT, PUBLISHED IN STUDIO INTERNATIONAL, MARCH/APRIL 1976**

# It's worth thinking about . . .

To finance the system of conspicuous expenditure, an extraordinary credit network has been set up, which, when considered, reveals much of our real class situation. The earners of wages and salaries are alike in this, that most of them become quickly involved in a system of usury which spreads until it is virtually inescapable.

How many supposedly middle-class people really own their houses, or their furniture, or their cars? Most of them are as radically unpropertied as the traditional working class, who are now increasingly involved in the same process of usury.

In part it is the old exaction, by the propertied, from the needs of the unpropertied, and the ordinary middle-class-talk of the property and independence which make them substantial citizens is an increasingly pathetic illusion.

One factor in maintaining the illusion is that much of the capital needed to finance the ordinary buyer comes from his own pocket, through insurance and the like, and this can be made to look like the sensible process of accumulating social capital.

What is not usually noticed is that established along the line of this process are a group of people using its complications to make substantial profit out of their neighbours' social needs.

As we move into this characteristic contemporary world, we can see the supposed new phenomenon of classlessness as simply a failure of consciousness.

# Class consciousness
## think about it

Circumspection in the achievement of goals is to be positively valued.

FROM VI, 1973, ONE OF TEN SECTIONS, EACH 12 x 18 INCHES

The *recognition seme* cannot be said to belong to an equivalent level of articulation to that of the phoneme as it has, by definition, intrinsic meaning. It must therefore be decomposed into atomic constituents of expression which have no counterpart on the content plane. The difference between recognition semes and semantic markers is illustrated in their respective decompositions. Katz says that each of the concepts represented by the semantic markers in his analysis of the sense of 'chair' may itself be decomposed. For example, he writes, "...the concept of an object represented by '(Object)' might be analysed as an *organisation of parts that are spatio-temporally contiguous which form a stable whole having an orientation in space.*"

A recognition seme might be decomposed as follows. Consider the example of two silhouette heads which are identical in all features except the nose one is 'aquiline' the other 'retroussé'. The *gestalt* in this case is 'head' which may be decomposed into the recognition semes (throat), (chin), (lips), (nose), (brow), (crown), (nape). We are accustomed to seeing the seme (nose) rendered schematically (via another iconic interpretant) as two lines. One line is horizontal, the other, about twice the length of the first, meets one end of this horizontal line at an angle of about 60°. The seme (nose) in this example may thus be decomposed into 'lines' (more accurately, perhaps, 'changes in direction and segmentation of line'), and the other semes might be similarly dealt with. *These lines have no intrinsic meaning.* The change of significance from 'aquiline' to 'retroussé' is thus brought about by the modification of an expression element which has no counterpart in the content plane.

Once commutation is established paradigms follow. In "Identikit" pictures a great many tokens of the type 'face' are generated by combining recognition semes drawn from paradigms established through changes in a small number of expression elements (lines, shadings, and their relations) which in themselves have no significance. Although the argument at this point concerns iconic signs of a different type from that of photographs the implications for the photographic sign should be clear.

**In the Service of the People** was written by Mao in memory of the soldier Zhang Si-de. Lei-Feng knows the essay perfectly and does not understand why he must return to it now.

FROM LEI-FENG, 1974, ONE OF NINE SECTIONS, EACH 20 x 30 INCHES

MY WORK FROM 1973 TO 1976 HAD ALL BEEN WHAT TODAY IS
called 'appropriated image' work. I was recycling advertising imagery and
reproducing the rhetoric of advertising copy. Part of the intention was to
deconstruct the ideological division between the inside and the outside of the
gallery. On the one hand, the work on the gallery walls looked like the sort of
image-text constructions you encounter in the street, and in magazines. On
the other hand, I did do work which was placed actually *in* the street, and *in*
magazines. I also treated advertisements for my exhibitions as works, so that
the gallery wall dissolved into the page of the magazine. For example, my first
solo show in New York was page ten of the January 1976 issue of *Artforum*:

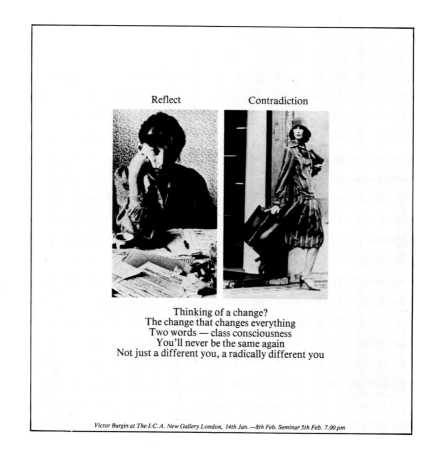

Reflect    Contradiction

Thinking of a change?
The change that changes everything
Two words — class consciousness
You'll never be the same again
Not just a different you, a radically different you

*Victor Burgin at The I.C.A. New Gallery London, 14th Jan.—8th Feb. Seminar 5th Feb. 7.00 pm*

Sensation

ContraDiction

Logic

Create a little sensation
Feel the difference that everyone can see
Something you can touch
Property
There's nothing to touch it

You've got it
You want to keep it
Naturally. That's conservation
It conserves those who can't have it
They don't want to be conserved
Logically, that's contradiction

Everything you buy says something about you
Some things you buy say more than you realise
One thing you buy says everything
Property
Either you have it or you don't

SENSATION, 48 x 100 INCHES, 1975

IN THE SECOND ISSUE OF *NOVY LEF* (1927) TRETYAKOV HAD WRITTEN:

"…The whole of academy art ranged itself against *Lef*. Academy art was economically powerful for it had once again found its old, well-tried consumer. It demanded a licence to trade and this was obligingly granted in the shape of the formula about 'assuming the cultural heritage'."

The position of *Novy Lef* on the 'cultural heritage' question was unequivocal: "To the easel painting, which supposedly functions as 'mirror of reality', *Lef* opposes the photograph — a more accurate, rapid and objective means of fixing fact.

"To the easel painting — claimed to be a permanent source of agit — *Lef* opposes the placard, which is topical, designed and adapted for the street, the newspaper and the demonstration, and which hits the emotions with the sureness of artillery fire."

'SOCIALIST FORMALISM', STUDIO INTERNATIONAL, MARCH/APRIL 1976

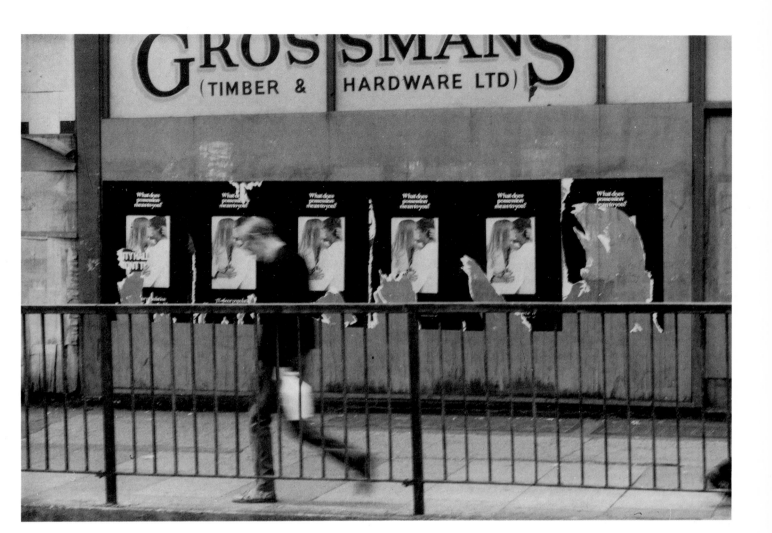

**1st voice (old man):** That's a lie, that's a lie. I could put on one finger what I own … I started work in 1912 and I'm nearly 79, and I done 13 year in the forces and was wounded and decorated in the First World War, and I'm lucky to get me dinner.

**2nd voice:** Well, it's something you can't dispute. I think most people are aware of it.

**3rd voice (girl):** When you look at the message on the bottom, why, it's stupid … unless it's trying to say 7% of the population who've got the wealth are the men … could be that.

**4th voice:** As posters I think they're rather disturbingly pop to me: the words and the poster just don't seem to go together.

**5th voice:** Beautiful. 'What does possession mean to you? 70% of our population…'

**ET:** Not 70%, 7%.

**5th voice:** '7% of our population own 84% of our wealth.' That's great that, isn't it? S'that all you want, like?

**ET:** But if somebody tells you that, does it make you feel angry or feel that it's unjust or what?

**5th voice:** Oh, I think it's a bit unjust, like…

**6th voice (woman):** Well, possession means to me a lot. Do you mean about wealth or what it means? Well, we worked hard enough at our own cottage … and I'm 75 and I've had a lovely life. I think you work for what you get and I think people are selfish and greedy otherwise … I do really, you've got to work for what you want pet, and that's work. I don't think you get … unless of course it's handed down to you on a silver platter.

**7th voice:** There's an enormous amount of wealth concentrated in a very few hands; as a result I think a lot of people are very dissatisfied. I think these posters bring the thought to mind because not many people read *The Economist.*

**8th voice (old man):** It's a very good poster but ya see worse than that in the streets of a night-time … they're cuddling each other and kissing each other in the middle of the bloomin' street. Well, it's only affection, isn't it? Not passion.

**ET:** But it makes you look at them?

**8th voice:** Yes, it makes you look at them … oh, it draws your attention to the poster. Yes, ha, ha…

**9th voice (girl):** It's just a nice picture … what does possession mean? Difficult question that, isn't it? Material things don't mean anything to anyone really; well, they might to some people, but they don't to me, that much. I like to have them, but they don't mean so much as having possibly somebody.

**ET:** You read it as 'What does passion mean to you?' That was a slip, it says 'Possession'.

**10th voice:** Ay, I did. That's what I thought it was … passion … I was just lookin' at the picture and that caught me eye … I think that's wrong, that 7% of the population should own 84% of the wealth. I'd rather have some 'cos I'm on the dole … I would. It's wrong that they should have it all when I've got no money, like. It's making us angry while I'm standing here watching it.

**11th voice (old man):** Well … 7% … 7% of our population own … gerraway, ya na that's a lie an' all.

STREET INTERVIEW BY EIRLYS TYNAN, RADIO NEWCASTLE BROADCAST, 7 JULY 1976

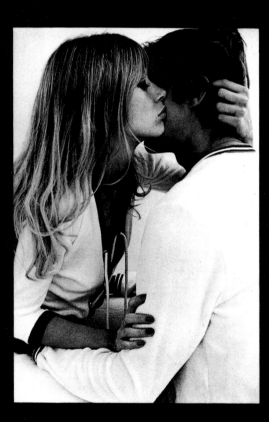

POSSESSION, 43 x 33 INCHES, ORIGINAL IN COLOUR, 500 COPIES POSTED IN THE STREETS IN THE CENTRE OF NEWCASTLE UPON TYNE, SUMMER 1976

*Now that poster was displayed in the streets, isn't that a more appropriate place than the galleries for your work?*

In answer to your very first question I said that I consider 'art work' to be a matter of working, wherever possible, across the totality of the art institution, not just a matter of single 'works' or objects. The question you could have asked then, and I think it's implicit in the question you've just asked, could have been: 'Why work, as a socialist, *at all* within the art institution? Isn't the art institution irretrievably bourgeois?' In fact I'm frequently asked: 'How can you *morally* justify working within it?' As a materialist I would say that it is not a moral issue; it's a question of one's political analysis. There's a certain 'marxist' notion of the nature of such institutions that goes like this: Those various institutions whose major concerns are with ideas — education, art, religion, advertising, and so on — are a projection of the 'economic base' of society. If we change the relations in the base, the institutional 'superstructure' will change automatically — much as, when you change the slide in a projector, the picture on the screen changes. So, it is only after collectivising the farms and occupying the factories that advertising will wither away, art will change its colours, the legal system will stop serving the interests of the rich at the expense of the poor, and so on.

That is a version of change that it is possible to derive from Marx, but Marx never actually said anything so simple. Engels himself towards the end of his life, when marxists were sprouting out of the ground like mushrooms, spent some time writing letters to them saying in effect, 'Marx and I never said that. What we said was that the economic is the determining factor *in the last instance*, but there are a great many complex intermediary operations.' At this point, skipping Gramsci for the sake of brevity, we have to invoke Althusser and the classic marxist version of the state, which holds, quite simply, that the state serves to perpetuate the vested interests of the ruling classes. Althusser said that the state, in order to perpetuate the status quo, has two arms: one arm wields a big stick

(this is the violent arm: police, army, prisons, etc.) but it prefers to keep that behind its back in the interests of good public relations. Its other arm is what Althusser calls the 'ideological state apparatuses' and these are not obviously violent or coercive: advertising, the family, trade unions, art, religion, education, and so on.

In order that the status quo be maintained it is necessary, first of all, that the means of production be reproduced; machinery that has worn out has to be replaced, more raw materials have to be found. It is also necessary for the workers to reproduce themselves in order to run these machines, so workers grow up and become big workers and get together and have little workers who grow up to be big workers, and so on. However, it is necessary not only that workers reproduce themselves biologically, but that they reproduce themselves *ideologically;* otherwise the little worker, as he or she gets older, might say to himself or herself: 'I'm not going to work at this tedious job, at this miserable pay, just so somebody else can afford to run a Rolls.' The worker must grow up thinking, 'Well, it's a fair society on the whole and if I work hard and continue clocking in then one day I'll have a nice house and maybe go scuba-diving with that blonde just like in the Martini advert.' It is the function of the ideological state apparatuses to ensure the reproduction of such ideology.

Given this instrumentality and efficacy of ideology, independently of the economic (until the 'last instance', which, as Althusser says, never comes) then it becomes necessary to intervene *within* the ideological state apparatuses, which means intervening within the schools (which are most important) and all the other institutions, of which art is one. As Althusser puts it, these institutions are not merely the *stake* of class struggle, but the *site* of class struggle. What that means is, as I said earlier, that the scenario is *not* that we first have the revolution: blood coursing in the gutters, capitalists swinging from the lamp-posts, and *then* we raise the red flag over the Tate and the Hayward, but that we struggle every day within the institutions in which we work.

INTERVIEW WITH TONY GODFREY, RECORDED IN 1979, PUBLISHED IN BLOCK 7, 1982

19

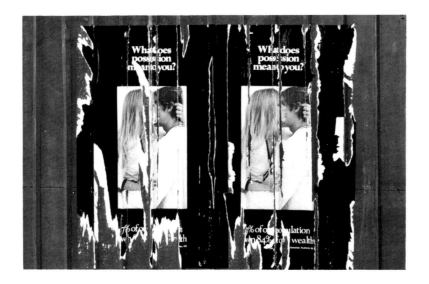

*Let's return to the poster work at Newcastle we mentioned earlier, for these issues of both accessibility and effectivity are clearly raised. It was done for an exhibition in Scotland originally wasn't it?*

What happened was that the Scottish Arts Council commissioned a show of contemporary art which was put together by the Robert Self Gallery. They wanted a poster for the exhibition: it was suggested that one of the artists do it and as I was doing poster-like work it was offered to me. It was used therefore first in Edinburgh. It wasn't entirely what they expected and, as I heard, wasn't entirely welcomed in certain sectors of the Scottish Arts Council. But the exercise was one of getting a certain message onto the street — again, a pretty vulgar notion of how we can confront false consciousness with the naked truth.

*Surely it isn't that crass: it is a fairly open-ended work: the relation-*

*ship of text and image is apparently arbitrary so that it works more by connotation than denotation.*

It works at both levels. It had to be simple, because people don't go around reading long-winded posters, and it had to be eyecatching. The punchline had to be short and straightforward: if you read it quickly it read just as a piece of information; likewise with the image, which represented a stock situation. But, of course, if you ponder the relationships of the three elements 'connotatively' then it raises all sorts of questions about property relationships, sexual relationships that become property relationships, and so on.

*Subsequently, five hundred copies were posted up in the streets of Newcastle. A short survey of people's reactions was later printed in* Studio International *— viewed as a statistical survey it was of course invalid for lack of numbers — in which it transpired that only one out of seven people interviewed had understood what the poster said, let alone implied. Surely this kind of low receptivity, especially to unexpected information and nonstereotyped notions, is a desperate problem in this kind of work.*

As you say, it wasn't a valid survey; even accepting that, you should maybe add that the one in seven who got the point was out of work. But, yes, I did it once and that was it. I did it very largely to show what *might* be done in that direction, 'to encourage others'. I wouldn't personally do it again because of several things, among them the notion of ideology involved. Again, more importantly, *vis-à-vis* what I just said about institutions, that was an intervention in the area of advertising, and advertising is not the institution in which I am organically rooted. I could only intervene in that area with great difficulty — there was no way I could sustain a continuing effort there.

INTERVIEW WITH TONY GODFREY, RECORDED IN 1979, PUBLISHED IN BLOCK 7, 1982

22

"These two images come from a set of photographs commissioned from me in 1976 by the National Community Development Project and the Coventry Workshop for use in their publications.

"With the addition of text the images were used again that same year in an exhibition in a London art gallery: shown here are two of the eleven interrelated panels.

"Different contexts, therefore different practices. Some people believe they can work 'outside' institutional contexts — this is unrealistic, the various institutions which form society fit together as closely as the pieces of a jigsaw puzzle.

"Most of my work is produced within the context of 'Art', within a set of concrete institutions: museums, galleries, magazines, etc. The question: 'How can artists directly assist ongoing workers' struggles?' is different from the question: 'What is the nature of class struggle *specific to the art institution itself?*' The questions are not mutually exclusive, but they need different answers.

"Each of the various institutions of society produces a particular discourse. Each discourse acts to guarantee what is 'true'. The totality of these discourses, in their intercirculation, forms the 'regime of truth' through which power and authority are exercised: society is *ordered* on the basis of what it holds to be true.

"Truth doesn't stand outside discourse, waiting to be 'expressed' by it; truth is *produced* by material forms of discourse inscribed in concrete practices. At this conjuncture, class-struggle specific to the art institution is struggle in and for its discourse — for that truth-in-power we know as 'culture'."

STATEMENT FOR THE WHITECHAPEL GALLERY, LONDON 1977

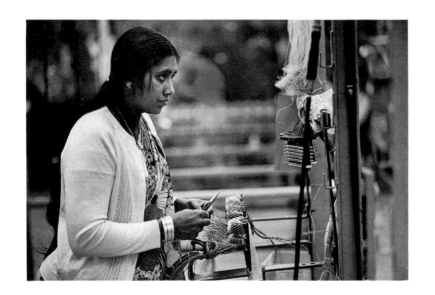

"OVER THE MODERN PERIOD WE CAN SEE THAT THE TASK OF VISUALLY representing people has come to be taken up almost exclusively by the so-called 'mass media' — cinema, television, photography, etc. (drawing remaining prominent in the form of comic strips). The mass media are far and away the *dominant* apparatus of visual representation. If we consider actual examples, what sort of picture do we get...?

"A cartoon published in *The Sun* shows British Leyland workers at the assembly-line — each is dressed in pyjamas and lying in bed. Spread out on the assembly-line itself is a variety of objects, prominent amongst which are children's games, jars of sweets, and children's comics. The argument, visually presented, is obvious: Leyland assembly-line workers are lazy and childish.

"In a BBC 2 television comedy programme, Spike Milligan interviews wives at an imaginary 'Husband of the Year' show. The husbands are in cages. The cage of the most brutish-looking man carries a sign which reads 'British Leyland Worker'; his 'wife' explains that, for exercise, he is allowed short walks to the Labour Exchange.

"Or again, in a copy of *Vogue*, David Bailey and Jean Shrimpton are in Egypt. In one full-page colour photograph Shrimpton is shown posed on a gang-plank which connects a luxurious yacht with the shore. Stooping at her feet, holding some sort of hand-brush, is a black man dressed in flunkey's clothes.

"The number of such examples could be multiplied almost indefinitely. Of these particular three images, the first is a black-and-white drawing, the second is colour video; what they have in common is the sort of representation they make of a certain group of people in our society. The third image is a colour photograph; it represents not only an idea of how a woman should look in order to be considered 'fashionable', but also an idea of the relationship of the Western world to the 'Third World' which lies outside our society. So long as we accept such representations solely at their face value — as 'only a joke', or 'just a fashion shot' — we remain susceptible to the picture of the world which they project, to their endless manufacturing of 'the first thing that comes to mind'. It is absolutely irrelevant, here, to make a fetish of any one particular *technology* of representation. The question is, rather, (speaking for myself): how and where are such representations to be contested? There are a number of possible sites available — I believe 'art' is one of them.

"Let me make clear what I mean by 'art', as no other word is more a source of obscurity. 'Art' and 'artists' are often spoken about as if both

were somehow extra-terrestrial; the real situation is of course simply that in which men and women make paintings, photographs, films, sculpture, etc. Such things are made within a particular social situation, within particular 'institutional spaces'. Thus, we may say that what 'art' *means* is simply the totality of institutions, practices, and representations, in respect of which the word is actually *used*: art museums, art schools … art history, art criticism … right across to representations of the artist in the popular media — Kirk Douglas's Van Gogh, Anthony Quinn's Gauguin, Charlton Heston's Michelangelo, and so on. At this point it becomes clear that the figure of the artist is itself a cultural stereotype, a product of dominant representations, just as much subject to ideological, political, and economic determinants as any other stereotype. (We might enquire into the function of such pictures of 'the artist' in a society which loudly eulogises individual freedom, spontaneity, and creativity, while systematically denying such things to the majority of its members.)

"Nothing which is the product of society can realistically be said to stand outside of it. The belief that art and artists are the exceptions which prove this rule belongs to what we call *ideology*. For our present purposes we can understand 'ideology' as consisting of those beliefs about the world, about ourselves, and about others, which we tend to accept 'without a second thought' as natural and unchangeable, when in fact they are man-made and thus open to revision. The French philosopher Louis Althusser has remarked that ideology as it were 'calls us' to itself, presents us with its picture and invites us to recognise ourselves in this picture as if the picture were in fact a mirror. For example, most of us in this country have been asked, at one time or another, to recognise ourselves in 'The British Character'. Mrs Thatcher was able to rely on this when in a recent television interview she appealed *on behalf of* 'The British Character', confident that this highly abstract notion could be presented to us as if it were actually something quite real, and thus capable of being threatened by 'alien cultures'. Such ideological representations rest upon unquestioned and emotionally-invested folk myths; thus, Mrs Thatcher was able to give 'The British Character' credit for 'British Justice' — which we were all taught at school to believe is our proudest export. Such popular beliefs belong to no particular ideology in themselves; they are largely free-floating items and thus may be appropriated by whatever ideological system chooses to appeal to them. We can clearly see today, for example, that much of the success of the Nazi party in 1930s Germany was due to its ability to orchestrate popular national mythology within the framework of fascism.

"What should be of *fundamental* interest to us, therefore, in regard to representations of people, is the way these representations help to determine subjectivity *itself*. Representation is a fact of daily experience which concerns us all *intimately*. We may tend to think that we were each born into the world as a little 'self', as well-formed psychologically as physiologically. Psychoanalysis, however, has built up a different picture: we become what we are through our encounter, while growing up, with the myriad representations of what we *may* become — the various positions that society allocates to us. There is no essential self which precedes the social *construction* of the self through the agency of representation. This observation brings me to the topic of *patriarchy*.

"We are all familar with the cultural stereotype of the woman: an essentially passive and dependent creature whose emotions rule her reason and whose exclusive aim in life is homemaking and motherhood. This version of essential 'femininity' is widely represented as being as inescapably natural to women as their biological gender. One of the achievements of the women's movement has been to point out the extent to which the collusion of women in their own repression is exacted *through* such representations. They have argued that the dominant representations of femininity are not based on a natural, and therefore unchangeable, model; it is rather that this supposed femininity is itself a *product of representations* — representations, moreover, overwhelmingly produced by men (the counter-part of the mother stereotype, the other side of the same patriarchal coin, is of course, the whore)."

FROM 'THE STATE OF BRITISH ART' DEBATE, ICA, LONDON 1978. TRANSCRIPT IN STUDIO INTERNATIONAL 2, 1978

# U K 7 6

**ELEVEN PANELS, EACH 40 x 60 INCHES, 1976**

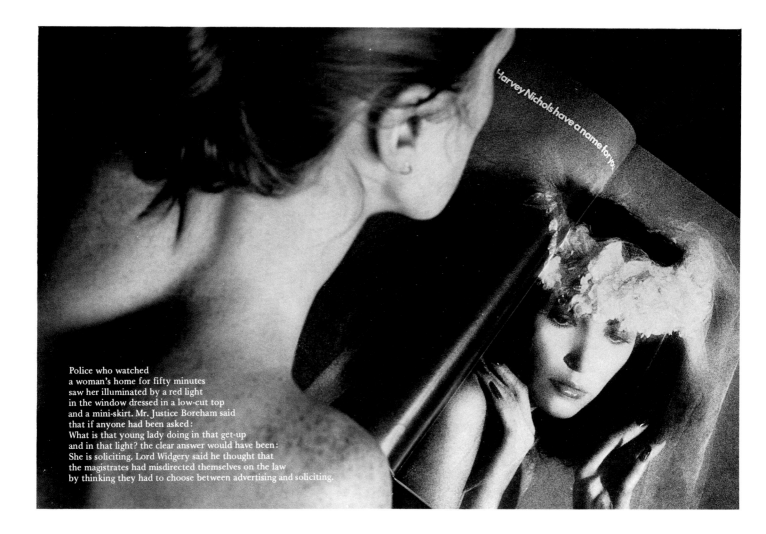

Police who watched
a woman's home for fifty minutes
saw her illuminated by a red light
in the window dressed in a low-cut top
and a mini-skirt. Mr. Justice Boreham said
that if anyone had been asked:
What is that young lady doing in that get-up
and in that light? the clear answer would have been:
She is soliciting. Lord Widgery said he thought that
the magistrates had misdirected themselves on the law
by thinking they had to choose between advertising and soliciting.

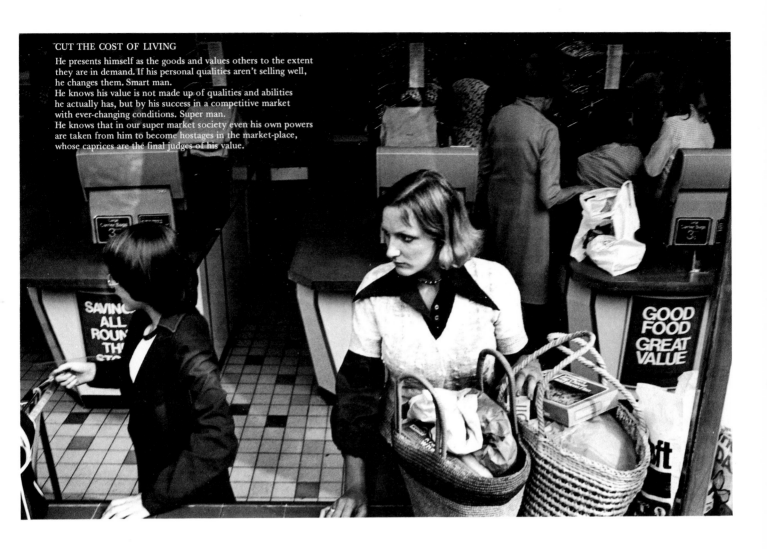

CUT THE COST OF LIVING

He presents himself as the goods and values others to the extent
they are in demand. If his personal qualities aren't selling well,
he changes them. Smart man.
He knows his value is not made up of qualities and abilities
he actually has, but by his success in a competitive market
with ever-changing conditions. Super man.
He knows that in our super market society even his own powers
are taken from him to become hostages in the market-place,
whose caprices are the final judges of his value.

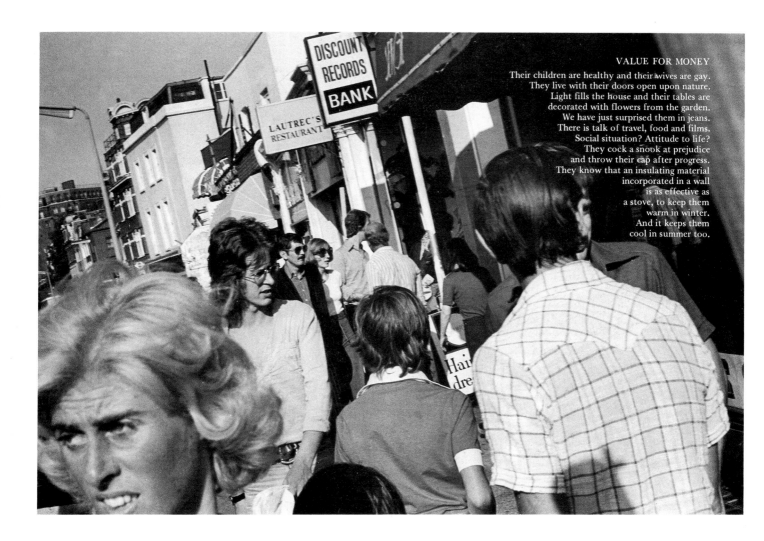

## VALUE FOR MONEY

Their children are healthy and their wives are gay.
They live with their doors open upon nature.
Light fills the house and their tables are
decorated with flowers from the garden.
We have just surprised them in jeans.
There is talk of travel, food and films.
Social situation? Attitude to life?
They cock a snook at prejudice
and throw their cap after progress.
They know that an insulating material
incorporated in a wall
is as effective as
a stove, to keep them
warm in winter.
And it keeps them
cool in summer too.

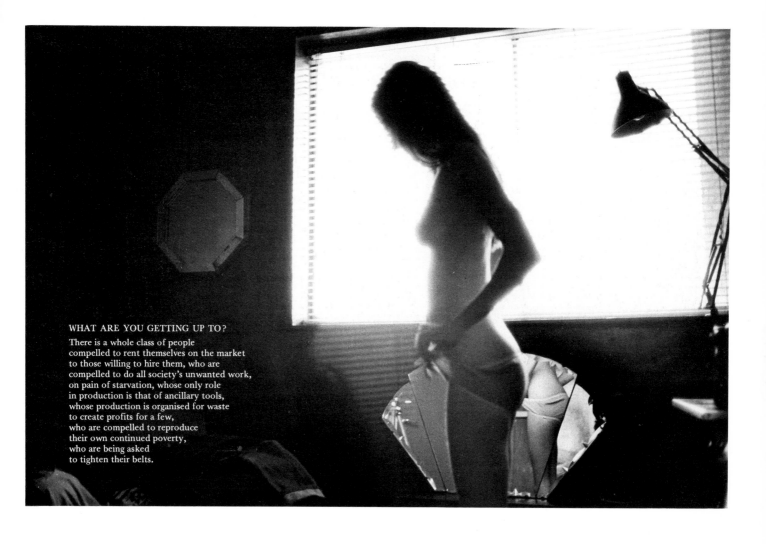

WHAT ARE YOU GETTING UP TO?

There is a whole class of people
compelled to rent themselves on the market
to those willing to hire them, who are
compelled to do all society's unwanted work,
on pain of starvation, whose only role
in production is that of ancillary tools,
whose production is organised for waste
to create profits for a few,
who are compelled to reproduce
their own continued poverty,
who are being asked
to tighten their belts.

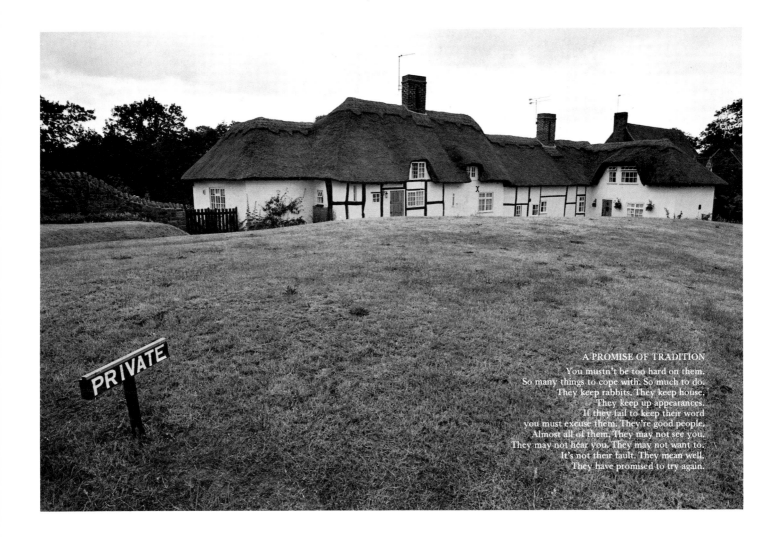

PRIVATE

A PROMISE OF TRADITION
You mustn't be too hard on them.
So many things to cope with. So much to do.
They keep rabbits. They keep house.
They keep up appearances.
If they fail to keep their word
you must excuse them. They're good people.
Almost all of them. They may not see you.
They may not hear you. They may not want to.
It's not their fault. They mean well.
They have promised to try again.

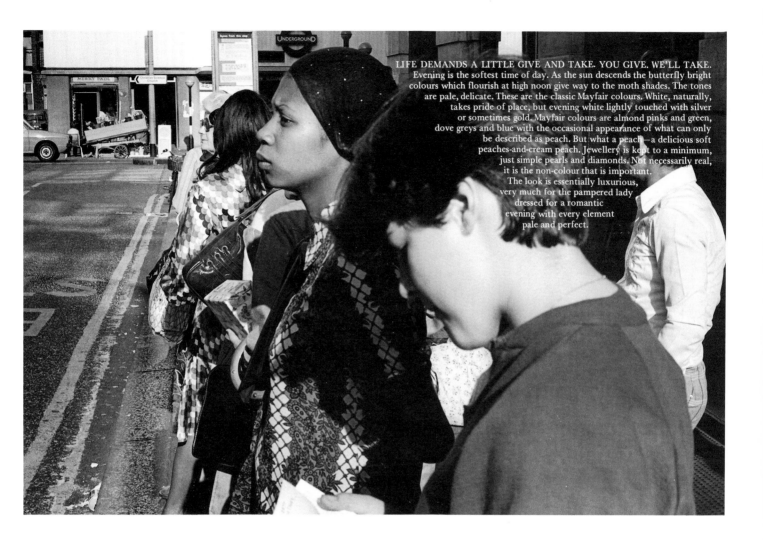

LIFE DEMANDS A LITTLE GIVE AND TAKE. YOU GIVE. WE'LL TAKE.
Evening is the softest time of day. As the sun descends the butterfly bright
colours which flourish at high noon give way to the moth shades. The tones
are pale, delicate. These are the classic Mayfair colours. White, naturally,
takes pride of place, but evening white lightly touched with silver
or sometimes gold. Mayfair colours are almond pinks and green,
dove greys and blue with the occasional appearance of what can only
be described as peach. But what a peach – a delicious soft
peaches-and-cream peach. Jewellery is kept to a minimum,
just simple pearls and diamonds. Not necessarily real,
it is the non-colour that is important.
The look is essentially luxurious,
very much for the pampered lady
dressed for a romantic
evening with every element
pale and perfect.

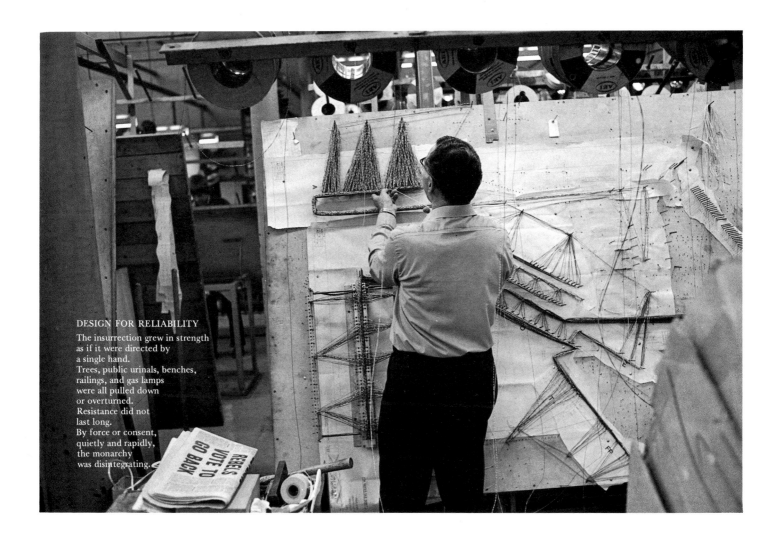

DESIGN FOR RELIABILITY

The insurrection grew in strength
as if it were directed by
a single hand.
Trees, public urinals, benches,
railings, and gas lamps
were all pulled down
or overturned.
Resistance did not
last long.
By force or consent,
quietly and rapidly,
the monarchy
was disintegrating.

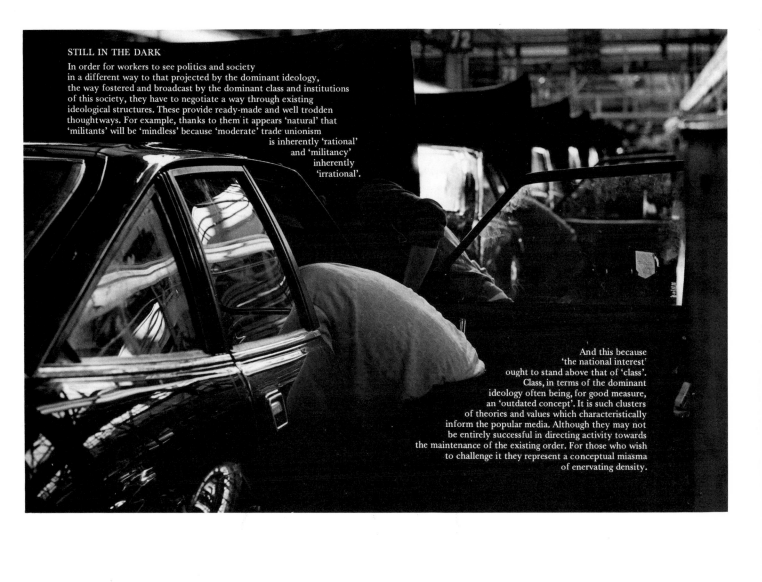

STILL IN THE DARK

In order for workers to see politics and society
in a different way to that projected by the dominant ideology,
the way fostered and broadcast by the dominant class and institutions
of this society, they have to negotiate a way through existing
ideological structures. These provide ready-made and well trodden
thoughtways. For example, thanks to them it appears 'natural' that
'militants' will be 'mindless' because 'moderate' trade unionism
is inherently 'rational'
and 'militancy'
inherently
'irrational'.

And this because
'the national interest'
ought to stand above that of 'class'.
Class, in terms of the dominant
ideology often being, for good measure,
an 'outdated concept'. It is such clusters
of theories and values which characteristically
inform the popular media. Although they may not
be entirely successful in directing activity towards
the maintenance of the existing order. For those who wish
to challenge it they represent a conceptual miasma
of enervating density.

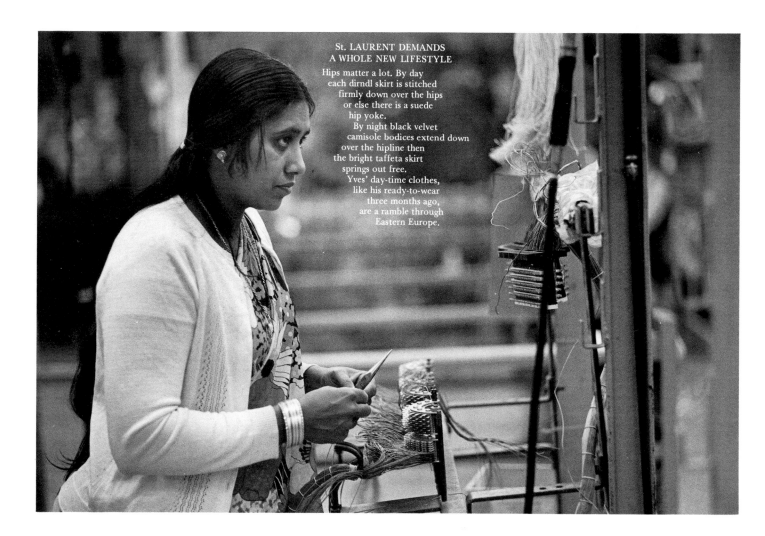

St. LAURENT DEMANDS
A WHOLE NEW LIFESTYLE

Hips matter a lot. By day
each dirndl skirt is stitched
firmly down over the hips
or else there is a suede
hip yoke.
    By night black velvet
camisole bodices extend down
over the hipline then
the bright taffeta skirt
springs out free.
    Yves' day-time clothes,
like his ready-to-wear
three months ago,
are a ramble through
Eastern Europe.

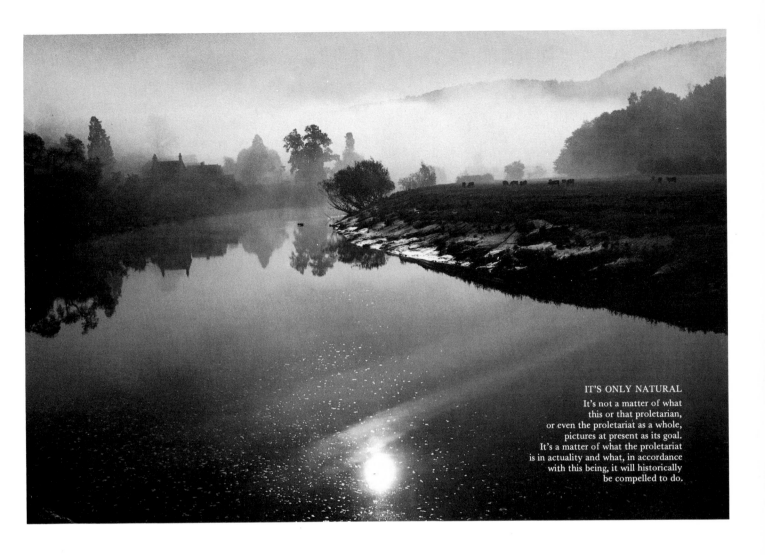

IT'S ONLY NATURAL

It's not a matter of what
this or that proletarian,
or even the proletariat as a whole,
pictures at present as its goal.
It's a matter of what the proletariat
is in actuality and what, in accordance
with this being, it will historically
be compelled to do.

The early-morning mist
dissolves. And the sun shines
on the Pacific. You stand like
Balboa the Conquistadore.
On the cliff top. Among the last of
the Monterey Cypress trees.
    The old whaler's hut is abandoned now.
But whales still swim through the wild waves.
    Sea otters float on the calmer waters.
Cracking abalone shells on their chests.
    Humming birds take nectar from the red hibiscus.
Pelicans splash lazily in the surf.
    Wander down a winding path. Onto gentle sands.
Ocean crystal clear. Sea anemones. Turquoise waters.
Total immersion. Ecstasy.

TODAY IS THE TOMORROW YOU WERE PROMISED YESTERDAY

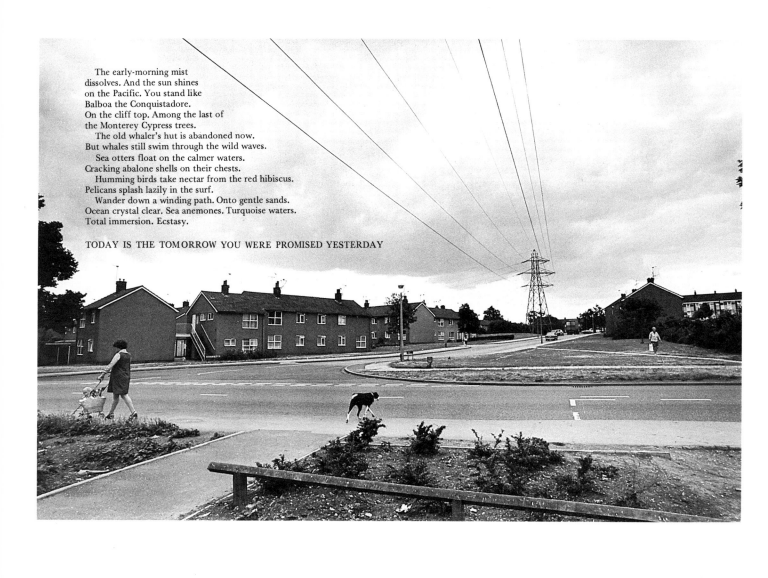

*How conscious are you of the power position of being the person taking the photographs? In the 'Saint Laurent Demands' panel you have taken a photograph of a person being exploited because of her sex and also presumably because of her race. Quite apart from the position that the camera places you in, you are economically in a relatively privileged position compared to her.*

It's a matter of weighing up the pros and cons. I'd been commissioned to take photographs by the Coventry Workshop, they were working with various other local workers' organisations and they wanted someone to take some pictures in some of the factories around Coventry. It was in that capacity that I took that particular picture: It was not shot as a work of art but as something for their publications and their files.

As to the actual situation of being there, no-one was photographed who didn't want to be. Some obviously didn't feel comfortable with the camera on them, so I didn't take photographs of them, but others obviously enjoyed being the centre of attention. I was a source of entertainment for them for the afternoon. Having said all that, the fact remains that I was free to walk out of that place and they weren't — a fundamental distinction. The work I was doing was intended to support them, the same goes for the art piece that some of the images were subsequently used in, but the fact remains that my intervention there, if not actually exploitative, was politically irrelevant; that's how I feel about it now, and that's how I feel about the work of other 'artists' who take their cameras into such situations.

INTERVIEW WITH TONY GODFREY, RECORDED 1979, PUBLISHED IN BLOCK 7, 1982

I NO LONGER HAVE SUCH A 'NEGATIVE' VIEW OF SUCH PHOTOGRAPHIC interventions. Some are useful, others not — only specific circumstances decide, and it is wrong to generalise. However, I would still say it is *particularly* wrong to make the sort of generalisation which automatically assumes that the photographer in this sort of situation is politically useful.

I WAS IN THE U.S. FROM '76 TO '77. I THINK OF THE WORK I MADE there as my 'road movie'. It can be seen as a sort of 'static film' where the individual scenes have collapsed inwards upon themselves so that the narrative connections have become lost. It represents the point in my work where a certain kind of feminist argument overcame my residual economistic marxism. The construction of sexual difference in representation becomes *the* issue. Why? Because patriarchal power relations, and the 'masculine' identity which supports them, are now seen as *the* problem. This is the point at which, for certain friends on the left, my work started to go astray.

# U S 7 7

TWELVE PANELS, EACH 40 x 60 INCHES, 1977

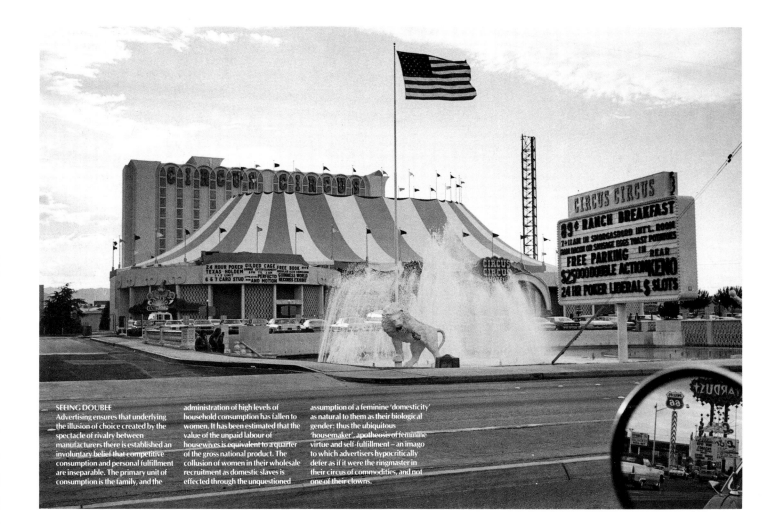

**SEEING DOUBLE**

Advertising ensures that underlying the illusion of choice created by the spectacle of rivalry between manufacturers there is established an involuntary belief that competitive consumption and personal fulfillment are inseparable. The primary unit of consumption is the family, and the administration of high levels of household consumption has fallen to women. It has been estimated that the value of the unpaid labour of housewives is equivalent to a quarter of the gross national product. The collusion of women in their wholesale recruitment as domestic slaves is effected through the unquestioned assumption of a feminine 'domesticity' as natural to them as their biological gender: thus the ubiquitous 'housemaker', apotheosis of feminine virtue and self-fulfillment – an imago to which advertisers hypocritically defer as if it were the ringmaster in their circus of commodities, and not one of their clowns.

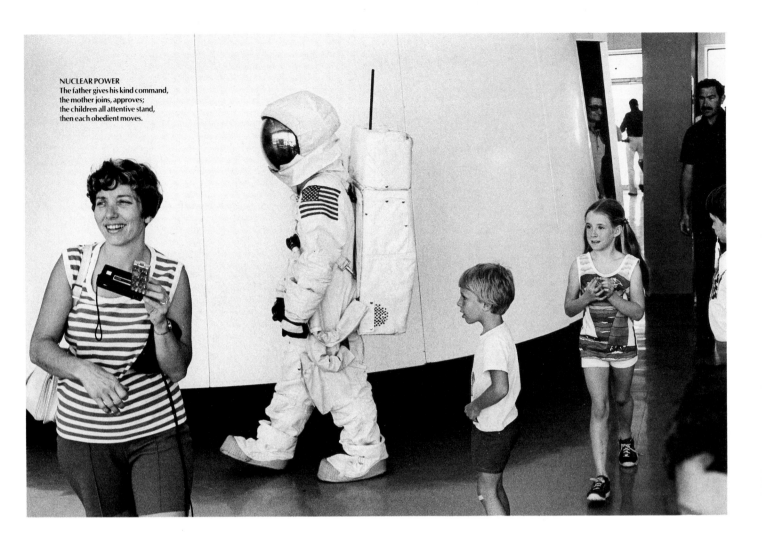

**NUCLEAR POWER**
The father gives his kind command,
the mother joins, approves;
the children all attentive stand,
then each obedient moves.

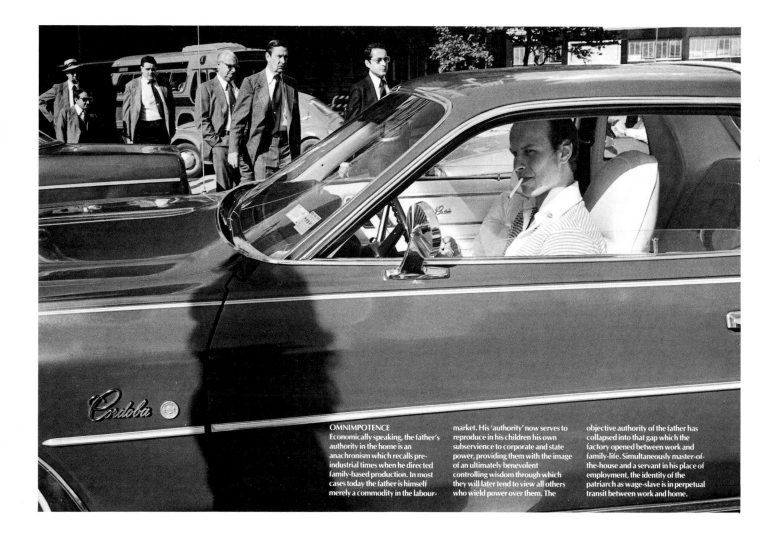

### OMNIMPOTENCE

Economically speaking, the father's authority in the home is an anachronism which recalls pre-industrial times when he directed family-based production. In most cases today the father is himself merely a commodity in the labour-market. His 'authority' now serves to reproduce in his children his own subservience to corporate and state power, providing them with the image of an ultimately benevolent controlling wisdom through which they will later tend to view all others who wield power over them. The objective authority of the father has collapsed into that gap which the factory opened between work and family-life. Simultaneously master-of-the-house and a servant in his place of employment, the identity of the patriarch as wage-slave is in perpetual transit between work and home.

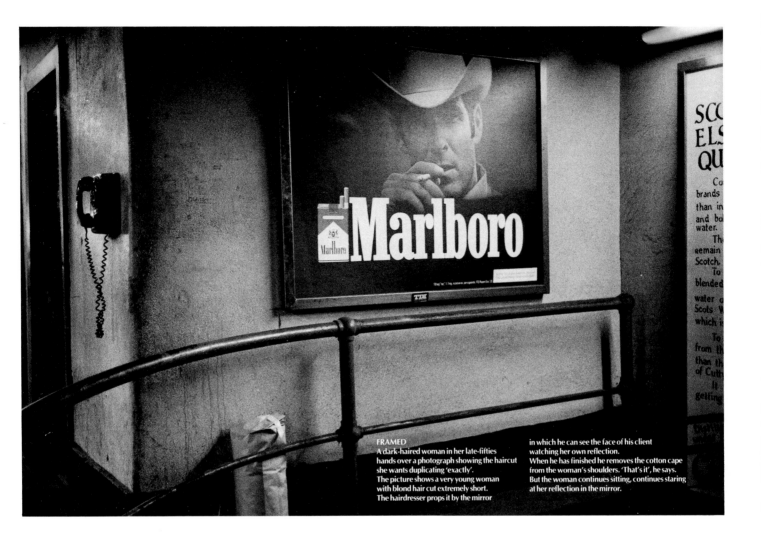

**FRAMED**
A dark-haired woman in her late-fifties hands over a photograph showing the haircut she wants duplicating 'exactly'.
The picture shows a very young woman with blond hair cut extremely short.
The hairdresser props it by the mirror in which he can see the face of his client watching her own reflection.
When he has finished he removes the cotton cape from the woman's shoulders. 'That's it', he says.
But the woman continues sitting, continues staring at her reflection in the mirror.

PHALLACY
She comes to theoretical conclusions.
He can explain everything,
including the necessity of theory:
'theories as precise as they are incorrect'.
You might judge that it absolves them from action;
but without theory, on what basis would they act?

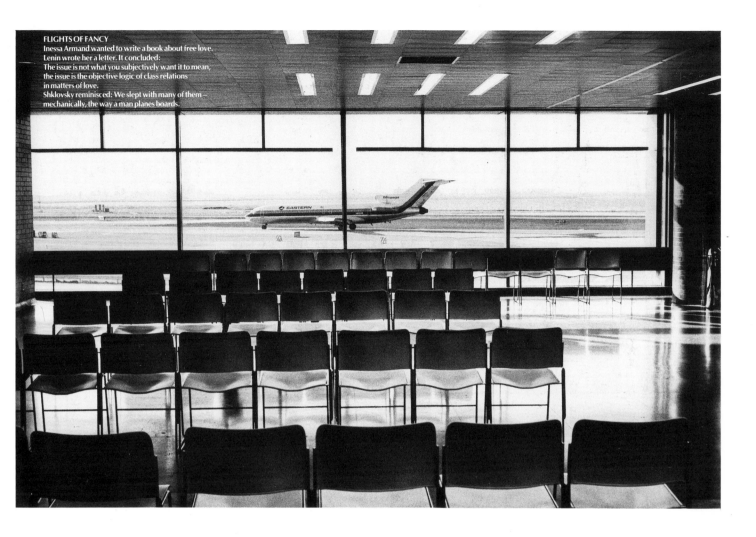

FLIGHTS OF FANCY
Inessa Armand wanted to write a book about free love.
Lenin wrote her a letter. It concluded:
The issue is not what you subjectively want it to mean,
the issue is the objective logic of class relations
in matters of love.
Shklovsky reminisced: We slept with many of them –
mechanically, the way a man planes boards.

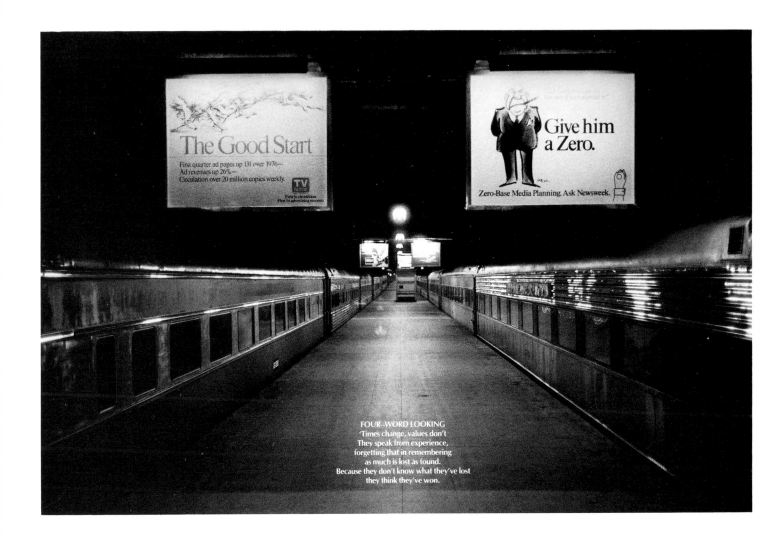

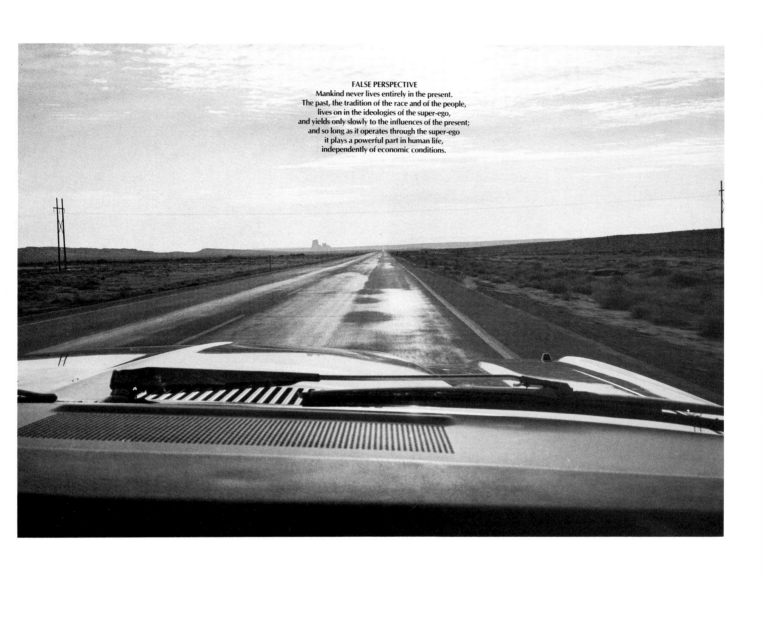

**FALSE PERSPECTIVE**
Mankind never lives entirely in the present.
The past, the tradition of the race and of the people,
lives on in the ideologies of the super-ego,
and yields only slowly to the influences of the present;
and so long as it operates through the super-ego
it plays a powerful part in human life,
independently of economic conditions.

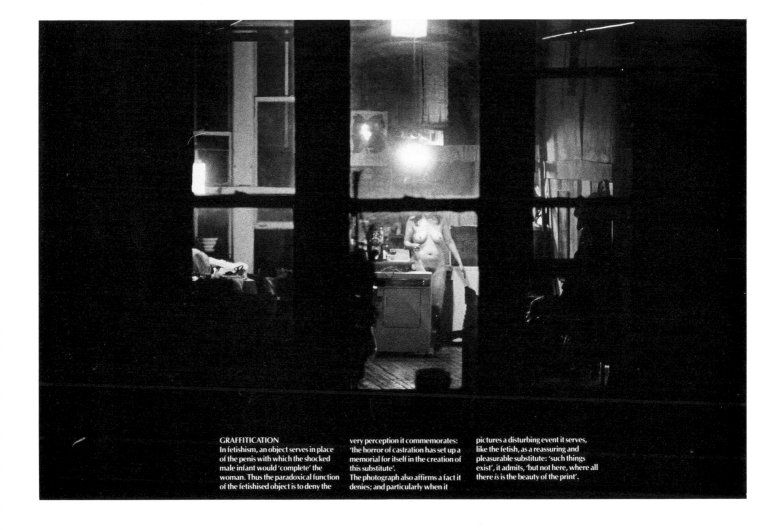

**GRAFFITICATION**
In fetishism, an object serves in place of the penis with which the shocked male infant would 'complete' the woman. Thus the paradoxical function of the fetishised object is to deny the very perception it commemorates: 'the horror of castration has set up a memorial for itself in the creation of this substitute'.
The photograph also affirms a fact it denies; and particularly when it pictures a disturbing event it serves, like the fetish, as a reassuring and pleasurable substitute: 'such things exist', it admits, 'but not here, where all there *is* is the beauty of the print'.

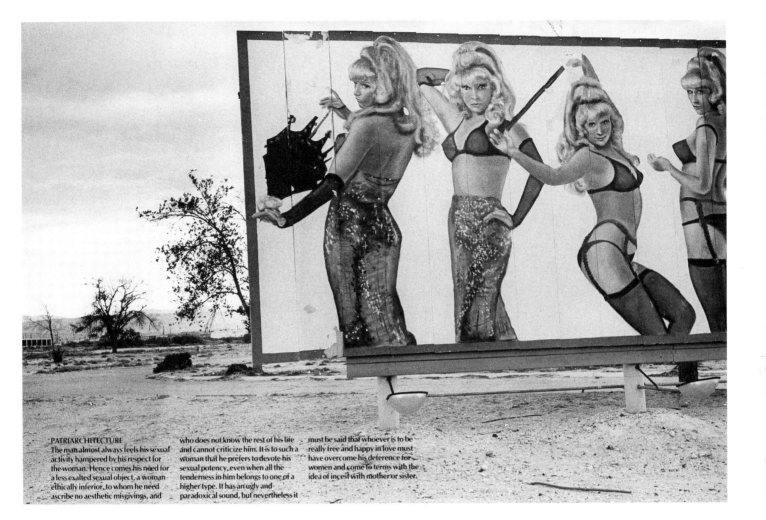

**PATRIARCHITECTURE**
The man almost always feels his sexual activity hampered by his respect for the woman. Hence comes his need for a less exalted sexual object, a woman ethically inferior, to whom he need ascribe no aesthetic misgivings, and who does not know the rest of his life and cannot criticize him. It is to such a woman that he prefers to devote his sexual potency, even when all the tenderness in him belongs to one of a higher type. It has an ugly and paradoxical sound, but nevertheless it must be said that whoever is to be really free and happy in love must have overcome his deference for women and come to terms with the idea of incest with mother or sister.

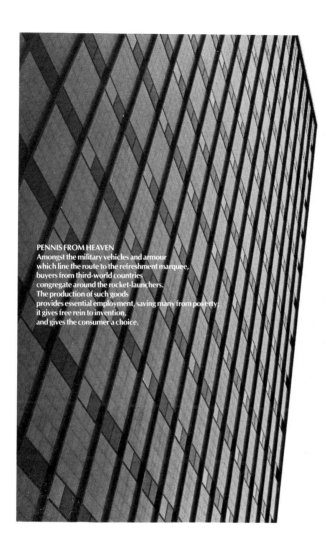

**PENNIS FROM HEAVEN**
Amongst the military vehicles and armour
which line the route to the refreshment marquee,
buyers from third-world countries
congregate around the rocket-launchers.
The production of such goods
provides essential employment, saving many from poverty:
it gives free rein to invention,
and gives the consumer a choice.

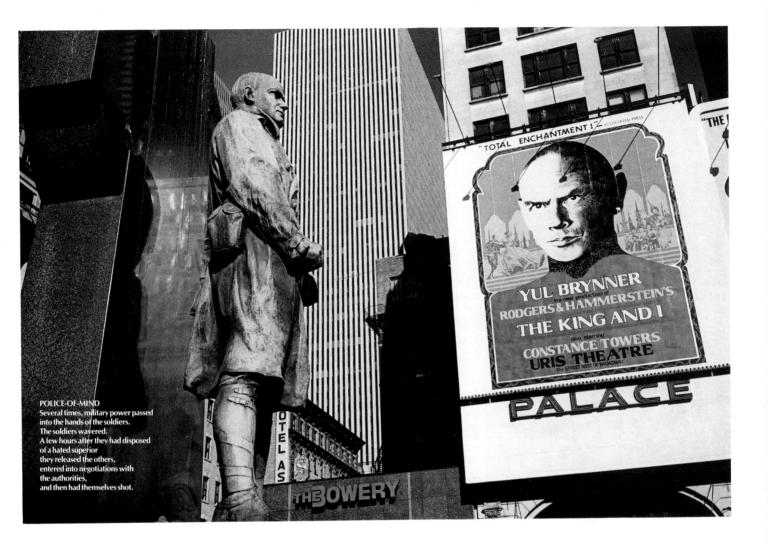

**POLICE-OF-MIND**
Several times, military power passed
into the hands of the soldiers.
The soldiers wavered.
A few hours after they had disposed
of a hated superior
they released the others,
entered into negotiations with
the authorities,
and then had themselves shot.

*The relationship with the street image. The monumental transient image of the advertisement was obviously something you were thinking about in the US series. The pieces themselves were all big, giving the impression of interior billboards. Police of Mind, for example, is a strong, spatial experience at that scale. Yul Brynner's head almost seems to come out at you from the space of the cityscape. It seems to reproduce that giddiness in looking up in New York, of being forced to look higher and higher and confronting representations which are proportionally bigger and bigger. The piece seems to be about this historical dominion of space ... the way that the monumental hero of an earlier epoque is dwarfed by the cinematic hero.*

It's interesting to me that you should say that, because although I was thinking about power relations in that panel, in the whole piece in fact, I never consciously gave the image that particular reading — a reading in terms of the power of the 'cinematic imago'.

*Well, Yul Brynner's head is a part of the walls which have boxed in the horizons which the stare of the soldier was intended to suggest. The soldier is dwarfed by becoming the object of the intimate stare of the cinema.*

When I did that piece, I was aware of something in that image which I felt was there for me — as a coherent meaning, but which escaped me. It's interesting for me personally because I feel you've just supplied the repressed meaning; repressed perhaps because, as a worker in a largely marginal art institution, I feel castrated when confronted with the cultural power of the movie industry.

*Like the old soldier? . . . But you are not merely powerless. The photograph exerts a power. It makes us see what we might otherwise overlook. It gives us a privileged perception of the coincidence of these different representations in space. There's a third vantage point — yours; the most powerful, the invisible one — the artist's or photographer's.*

Certainly the act of photography is an act of appropriation: it's also a way in which we can return the looks directed at us from advertising, and it can be an aggressive act, an act of revenge.

*Where does the idea of an image/text fusion come from? I think of the artist as film director — wholly in charge of the scenario. Cinema, I suppose, is the ultimate fusion of the word and the image. Working in series imposes an equivalent linear ordering of encounter with the image. Do you wish you were a film director?*

I do from time to time wish I was making films — but not because I'm unhappy with my own form of practice — it's rather that I'm unhappy with the conditions of distribution and consumption of that practice. It's like this — one works for an imaginary audience; now, for someone with my sort of theoretical and political concerns who makes films

there is a real audience to correspond to that imaginary audience, and there are modes of distribution for reaching that audience. More or less the same audience is potentially there for the type of work I produce — for example, I know there were a lot of people who went to the recent shows of feminist work at the ICA, and who went to the *Three Perspectives* photography show at the Hayward in '79, who never normally set foot in a gallery — but there's no corresponding distribution network. I made a large work in Berlin — *ZOO*. It's been shown once in England — at the Hayward in 1979 as part of the Annual — and it's unlikely that it will be shown again anywhere in this country. If I had made a film in Berlin, then that film could have gone several times round one or other of the university, and other, networks by now. Also, with film, there's always the possibility of moving into a more general audience arena — with art, if it's been hung in the Hayward, that's it — finished. As an avant-garde film-maker friend said to me: 'You're at the centre of a periphery — I'm at the periphery of a centre.' I spoke about this to another film-maker, and she told me that I overestimated the conditions for theoretical/political film-making — she said that you should consider the work as being one of *creating* an audience — but how is that possible without minimal access to the means of distribution?

*But isn't art inevitably peripheral? Most artists could feel that marginality is the price of independence.*

There's a position on the left in which 'art', indeed *any* form of cultural activity, is seen as 'peripheral' to the *real* world of party politics and economic class struggle. There's a position on the right which agrees with this and welcomes it as a 'guaranteeing the independence' of artistic creativity. You're then offered a choice as to which square to occupy on a checker-board of positions — any position as long as it's black or white. I think it's important not to accept any games played on this board. Cultural production, to which 'art' contributes, involves social relations and apparatuses, and has definite societal effects. Artists are not independent — socially, economically, ideologically, politically — for all it suits some of them to pretend that they are. But neither are they 'a cog and a screw' in the party machine.

*Your work uses a format which relates to a cultural mainstream of image use. Marginality seems to be an essential part of the strategy.*

I think what's at issue here is a metaphor. You use the word 'margin'. A margin is a space running along the edge of something to which it doesn't belong. I've used this term myself — 'society marginalises its artists and intellectuals' — that sort of idea. It's a metaphor which slips out easily, but I wonder if it's the most appropriate one. Maybe 'fringe' would be better.

If I've got it right, 'fringe interference' is what takes place where different wave forms encounter each other. If you throw three stones into a pond and watch the ripples, then there are places where those waves are encountering each other and producing something new. So 'fringe' allows for a more dynamic and de-centred picture than 'margin'. I feel I'm working across the fringe areas — for example, as I've said already, where 'art', 'advertising', 'documentary', 'theory', etc. overlap — but the very fact of cultural production then taking place in those areas of overlap means that 'ripples' then *emanate* from those points. Definitions of art change as a result — for example, the idea of what it's possible for an art exhibition to be *about*. The changes are resisted, but then the resistance becomes the very sign of change. Even exclusion, that *silent* form of resistance, marks a space which is destined to be occupied.

**INTERVIEW WITH ROSETTA BROOKS IN ZG, 1981**

*Here at the Polytechnic of Central London you lecture on photography: how would you describe the operations of this particular panel, 'Seeing Double', in that capacity.*

In fact, I don't teach from my own work. If I were to do so I probably wouldn't choose this one as an example to discuss, not all pictures are good examples for teaching. I use advertising photographs a lot because they are crystal clear, even simplistic. If I *were* talking about this one though I'd be talking about fairly obvious things, such as the way the caption 'seeing double' anchors certain aspects of the image, and further serves to link those aspects with the text. You can see this place is called 'Circus, Circus' so, already, a literal 'doubling'; the image includes a rear-view in the mirror so you're 'seeing double' there too: both the world before and behind you — picking up the theme of the present as transition that we discussed earlier. The text concerns *two* ways of seeing women in the home: as the advertiser presents her, in control of her home, choosing her products wisely; or as she also is, under their control. So this reiterates the duality of master/mastered present elsewhere in the work, for example in the dual male role described in *Omnimpotence*, of which this female role is a counterpart — these can be linked across the work via the image of the car: viewed from the outside, and then from the inside, looking out.

*So the photograph presents us with both an image and a meta-phor, the circus of society.*

Yes, it operates on the level of the literal and the level of the metaphorical.

*What about this one: 'Framed'? Could you say something about the exact relationship of text to image.*

We usually see words used to *comment* on the image in some way; for example, to give some extra information about what is shown in the image. Alternatively, we see an image used to illustrate a text — to show pictorially what has already been mentioned verbally. I tend not to do either of these things. To take this example: the 'keyword' *Framed* is used to relate together a number of pictured and 'written' frames: the frame of the panel itself; the frame of the Marlboro poster; the frame of the photograph described in the text; and the frame of the mirror in which the woman watches herself. Secondly, the word 'framed' — in the language of gangster

and cowboy films — has the meaning of the misrepresentation of an individual: the good guy is 'framed' by the bad guys. The cowboy in the poster helps this reading. Now this idea of being framed, of having a certain 'picture' of yourself imposed on you by others against your will, can then be attached to the stereotypes which are arranged as oppositions: young girl/middle-aged woman; male hairdresser/cowboy — these are clearly distinguished cliché representations of people used in the media, and in culture in general. We can go even further with this sort of reading, although you'll probably find this a bit extreme: the cowboy in the poster is smoking a cigarette; a slang term for a cigarette, in this country, is 'fag', and 'fag' is also a term of abuse used against homosexual men. And again, under the poster there's a bag, the term 'bag' is a similarly sexist insult used to describe a woman 'past her prime'. These sorts of 'literalisations' of elements in an image aren't often picked up consciously, but I think that they contribute to what we might call the 'unconscious' of an image — contribute to that certain 'taste' an image has and which we find so difficult to account for.

INTERVIEW WITH TONY GODFREY, RECORDED 1979, PUBLISHED IN BLOCK 7, 1982

IN ADDITION TO SUCH 'INTERNAL' PLAY, THE WORK OPENS OUT onto its context, the 'intertextuality' which constructs it. Thus, for example, the magazine and advertising conventions already mentioned, and the actual billboards which appear, 'quoted', in the work. Again, similarly, the phrase "theories as precise as they are incorrect" embedded in the text to 'Phallacy' is a quotation (Shklovsky speaking of Brik, in *Mayakovsky and his Circle*, p.150); or again, "Times change, values don't" in 'Four-word looking' is the slogan of a (still current) *Daily Telegraph* advertising campaign. Further, the entire texts of 'Patriarchitecture' and 'False perspective' are direct (albeit edited) quotations from Freud, and 'Police-of-mind' re-tells a story first told by Lenin (of mutiny in the Russian army in the 'run-up' to 1917). Thus, although 'I' took the photographs, and 'I' wrote (most of) the texts, the voices of others intrude, and even my 'own' voice is inconsistent in tone across the work, calling into question the ideology of the individuality and autonomy of an art-work and of its putative 'author'.

*You said earlier that you were interested in the problem of pleasure and referred to 'art photography' using the image as a source of fascination, in other words, appealing to voyeuristic tendencies, scopophilia; yet you could be accused of producing objects for voyeuristic participation yourself — in the panel entitled 'Graffitication', for example.*

This issue of visual pleasure is centrally important. Laura Mulvey, in an article called 'Visual Pleasure and Narrative Cinema' (*Screen, Autumn 1975*) argues precisely against the provision of such voyeuristic forms of pleasure. She used psychoanalytic theory, particularly Freud, to demonstrate the very great extent to which the pleasure of watching Hollywood cinema depends upon scopophilic syndromes — voyeurism, exhibitionism, fetishism. The look inscribed in such cinema is a male look, a controlling look, voyeuristic and sadistic, and the object of this look is the woman. Women are constructed in these films primarily as *images;* they're not strictly speaking *actors* at all, in the broader social sense of the word, they are essentially passive. Mulvey concluded that a politically progressive film practice would have to deny those pleasures. I agree with her observations, but not with her conclusion. I don't think it can be a matter of simply denying the voyeuristic impulse any gratification in your work, because that impulse will simply be diverted elsewhere. I took part in a symposium on feminism and photography in which one woman suggested that female photographers should simply absent themselves, and other women, from their work. Another woman replied that that wouldn't stop the copious supply of such images from other sources, such as advertising. The scopophilic drive is part of the general libidinal drive: there can be no question of stopping it, but there may be a possibility of reconstructing it and its objects in a form which isn't oppressive to women. Griselda Pollock put it neatly at yet another symposium when she said that for her it wasn't so much a question of 'feminism and photography' but of 'photographic practice and sexuality'.

*Which means . . . ?*

Well, she's invoking two contrasting pictures: in the first, a political movement is placed alongside, but essentially separate from, a technology it may or may not choose to employ; in the second, the very fact to which feminism is a response — sexual difference as a relation of oppression — is considered in its ongoing construction across photography, considered not simply as a tool, but as a specific and complex social practice. The key terms here are *construction* and *practice:* forms of representation such as photography don't simply express a biologically pre-given 'femininity' or 'masculinity'; sexual difference, in the totality of its effects, doesn't precede the social practices which 'represent it', doesn't function outside such

practices, but is constructed *within* them, *through* them. So the problem becomes not simply one of picking up a camera in order to express a pre-given concept of, for example, an *alternative* 'essential femininity', but rather one of looking at the whole way in which a practice like photography constructs such categories, and then developing a practice which will have sexuality inscribed in it in such a way that it is no longer oppressive.

*And how would you say you deal with that problem in your own work?*

Basically by confronting it head on: by the direct quotation of voyeuristic imagery in the context of a *critique*. At the time of *UK76* I was producing conventionally 'positive' images of women for use in my work — for example the immigrant worker in the panel with the caption referring to Saint Laurent. I'm not saying that the production of such 'positive' imagery isn't important, it should continue, but the other problem has become maybe more important to me as a man. It's no longer so much a question of 'images of women', but rather a question of 'woman-as-image' — one specific project I'm addressing is the interrogation of the 'male voice' as it is constructed across the specific discourses of photography. I'm trying to approach the question 'To what extent is the male-coded voice of sexual oppression the archetype of all oppressive discourses — the very pattern through which oppression-in-general is extruded in its particular forms?'

INTERVIEW WITH TONY GODFREY, RECORDED 1979, PUBLISHED IN BLOCK 7, 1982

# Zoo 78

EIGHT DIPTYCHS, EACH PANEL 32 x 36 INCHES, 1978-79

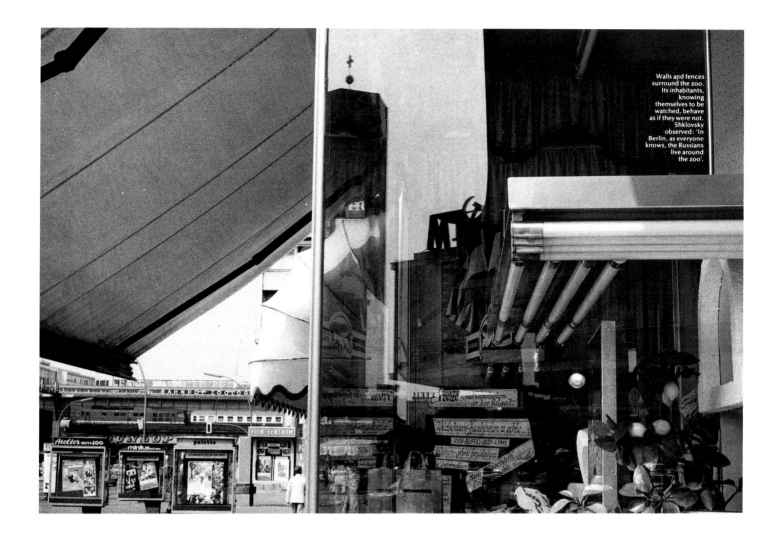

Walls and fences surround the zoo. Its inhabitants, knowing themselves to be watched, behave as if they were not. Shklovsky observed: 'In Berlin, as everyone knows, the Russians live around the zoo'.

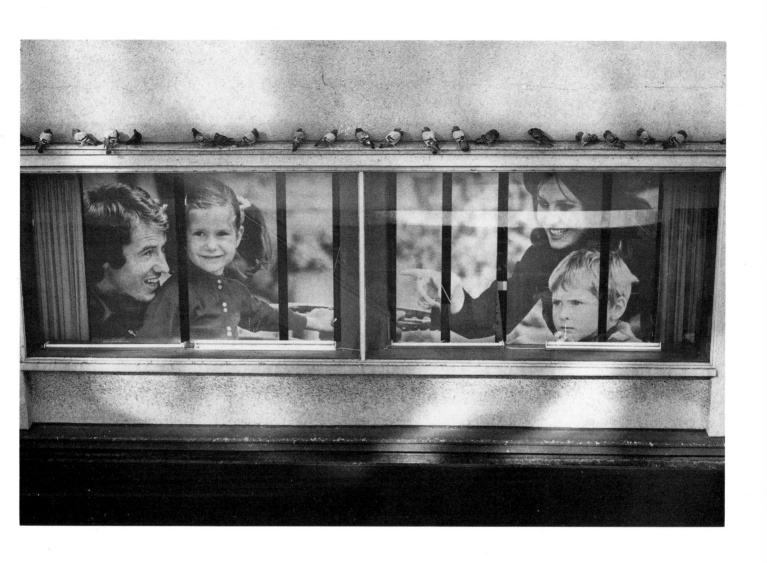

A bright clear day. The camera in the helicopter can pick out a single face from the streets below. The computer holds details on half the population, children having been excluded as uninteresting. She crosses the Kurfürstendamm under the hostile gaze of a small crowd who are waiting to receive permission to walk from an automatic signaling device.

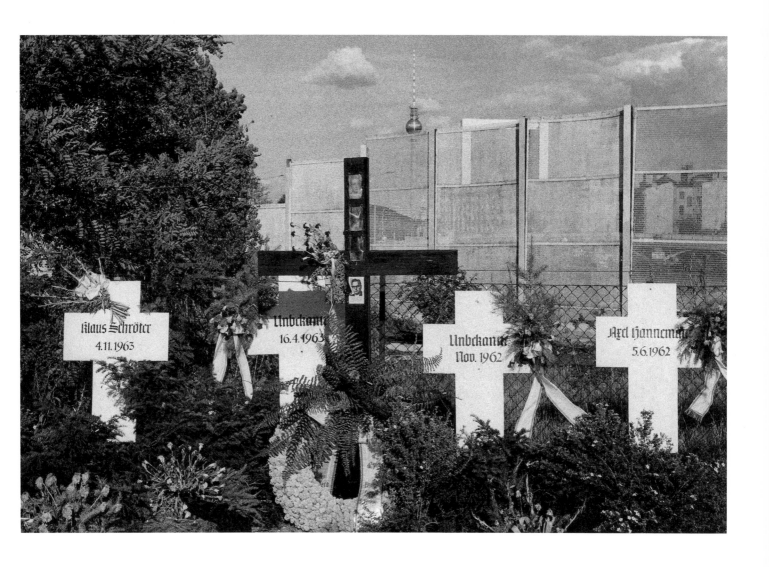

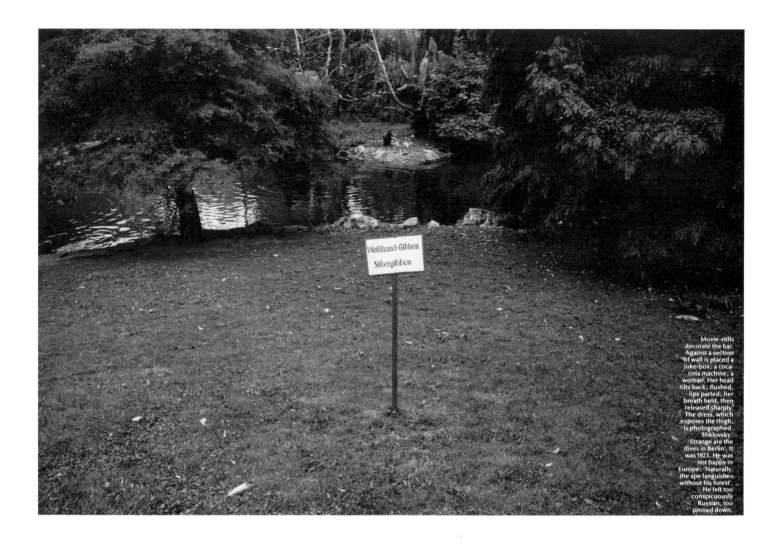

Movie-stills
decorate the bar.
Against a section
of wall is placed a
juke-box; a coca-
cola machine; a
woman. Her head
tilts back; flushed,
lips parted; her
breath held, then
released sharply.
The dress, which
exposes the thigh,
is photographed.
Shklovsky:
'Strange are the
dives in Berlin'. It
was 1923. He was
not happy in
Europe: 'Naturally,
the ape languishes
without his forest'.
He felt too
conspicuously
Russian, too
pinned down.

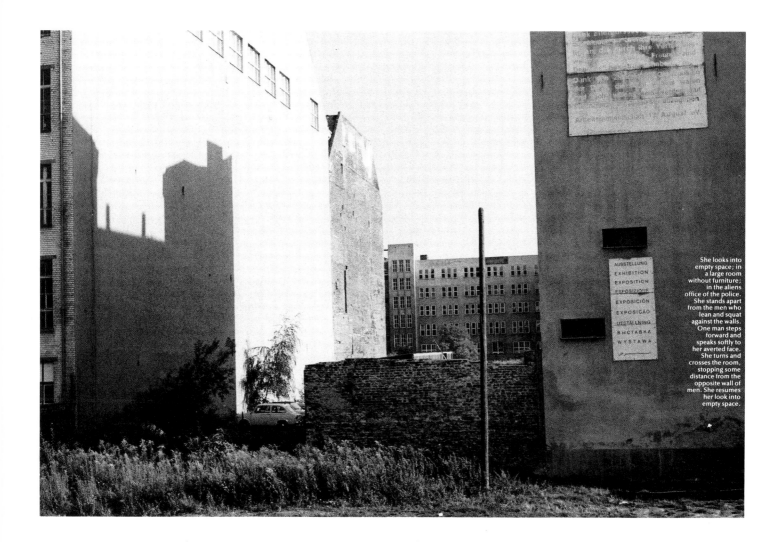

She looks into
empty space; in
a large room
without furniture;
in the aliens
office of the police.
She stands apart
from the men who
lean and squat
against the walls.
One man steps
forward and
speaks softly to
her averted face.
She turns and
crosses the room,
stopping some
distance from the
opposite wall of
men. She resumes
her look into
empty space.

AUSSTELLUNG
EXHIBITION
EXPOSITION
ESPOSIZIONE
EXPOSICIÓN
EXPOSIÇÃO
UTSTÄLLNING
ВЫСТАВКА
WYSTAWA

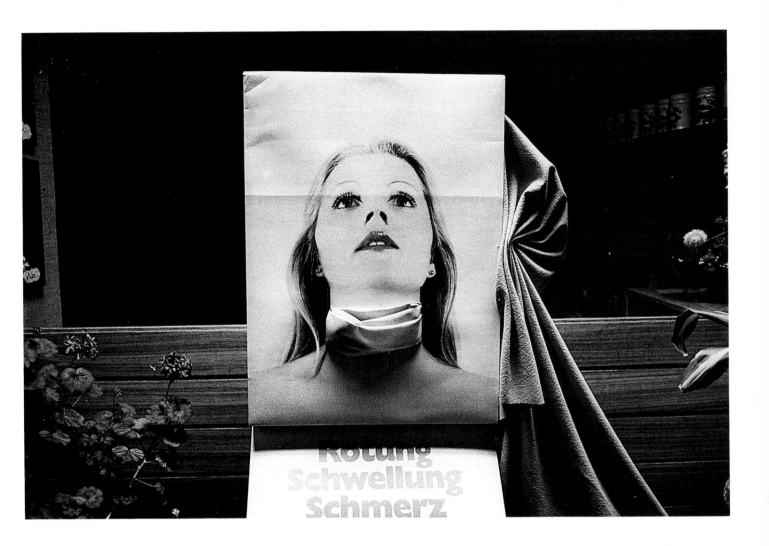

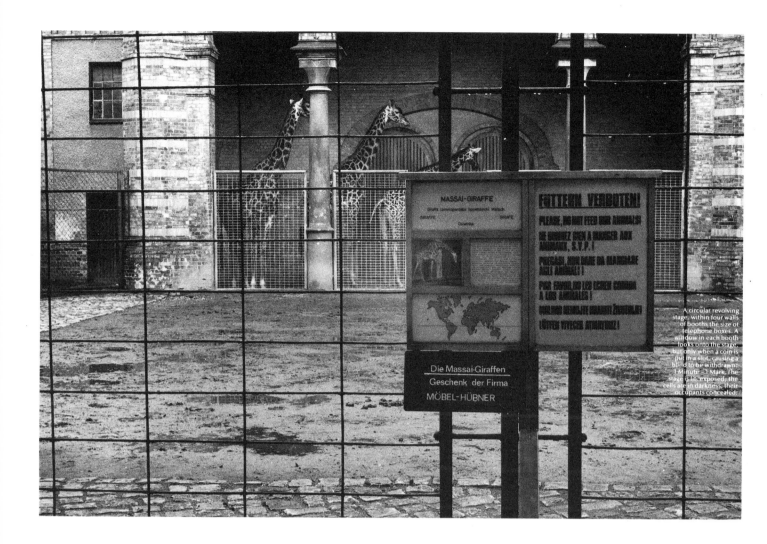

MASSAI-GIRAFFE

Die Massai-Giraffen
Geschenk der Firma
MÖBEL-HÜBNER

FÜTTERN VERBOTEN!

PLEASE, DO NOT FEED OUR ANIMALS!

A circular revolving stage, within four walls of booths the size of telephone boxes. A window in each booth looks onto the stage, but only when a coin is put in a slot, causing a blind to be withdrawn: 1 Minute = 1 Mark. The stage is lit, exposed, the cells are in darkness, their occupants concealed.

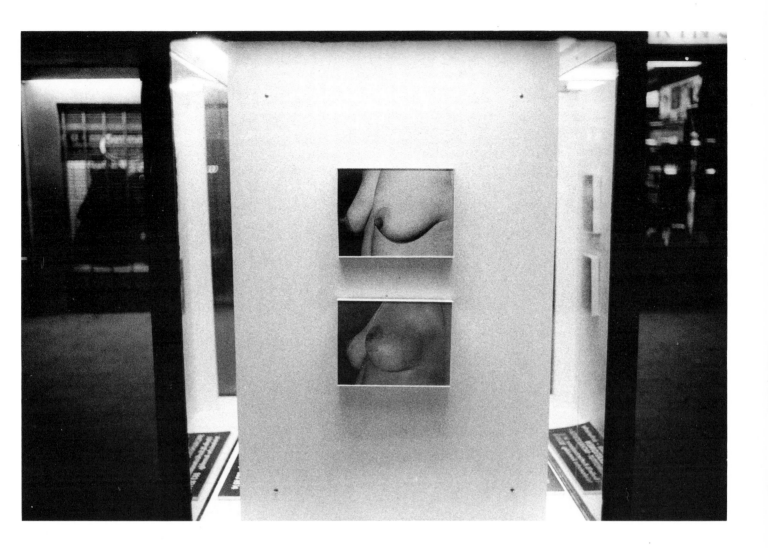

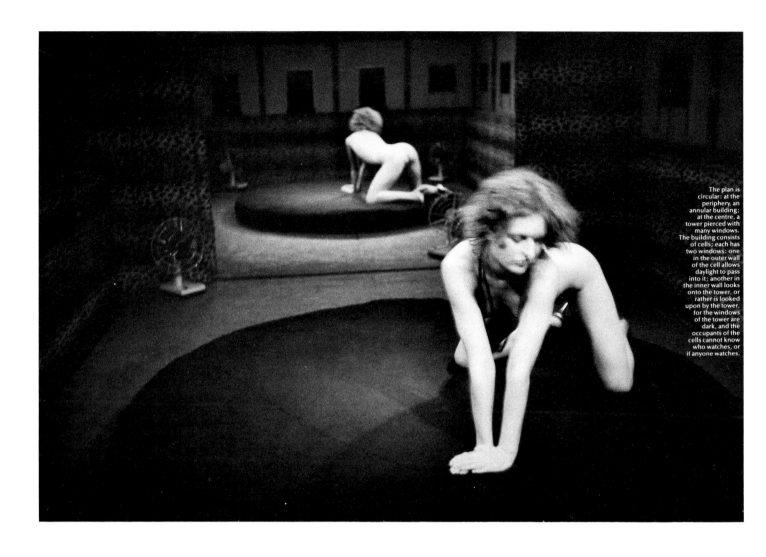

The plan is circular: at the periphery, an annular building; at the centre, a tower pierced with many windows. The building consists of cells; each has two windows: one in the outer wall of the cell allows daylight to pass into it; another in the inner wall looks onto the tower, or rather is looked upon by the tower, for the windows of the tower are dark, and the occupants of the cells cannot know who watches, or if anyone watches.

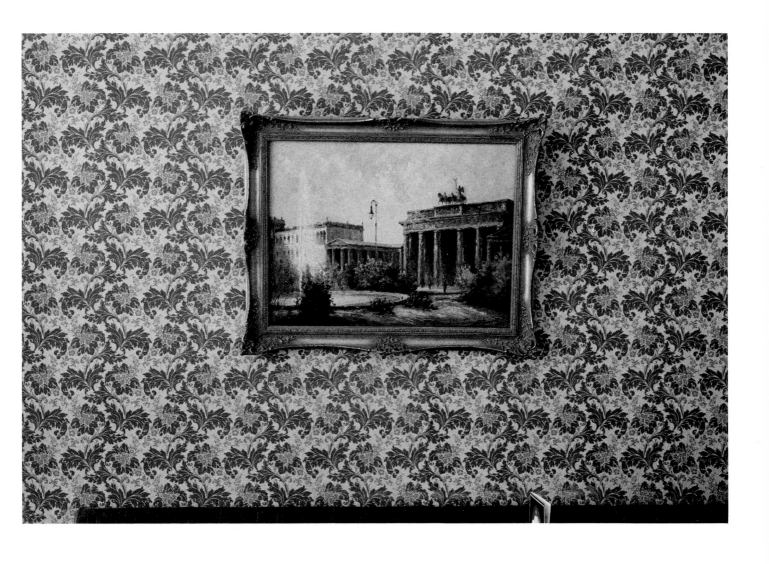

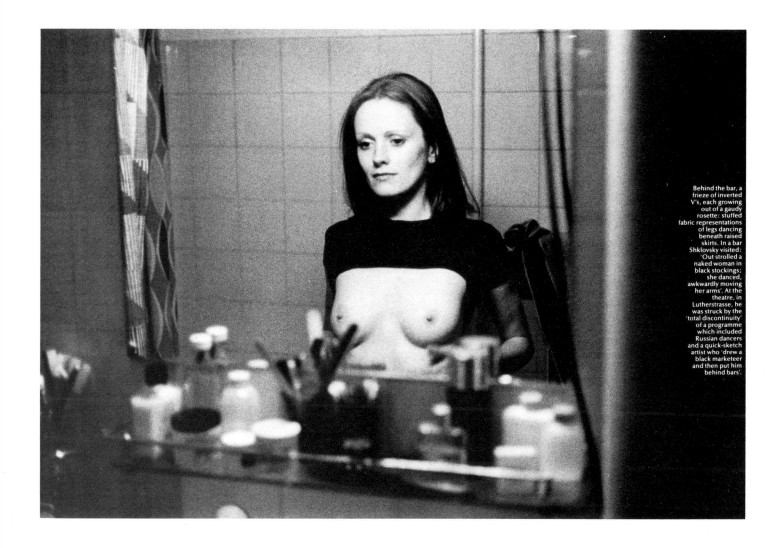

Behind the bar, a
frieze of inverted
V's, each growing
out of a gaudy
rosette: stuffed
fabric representations
of legs dancing
beneath raised
skirts. In a bar
Shklovsky visited:
'Out strolled a
naked woman in
black stockings;
she danced,
awkwardly moving
her arms'. At the
theatre, in
Lutherstrasse, he
was struck by the
'total discontinuity'
of a programme
which included
Russian dancers
and a quick-sketch
artist who 'drew a
black marketeer
and then put him
behind bars'.

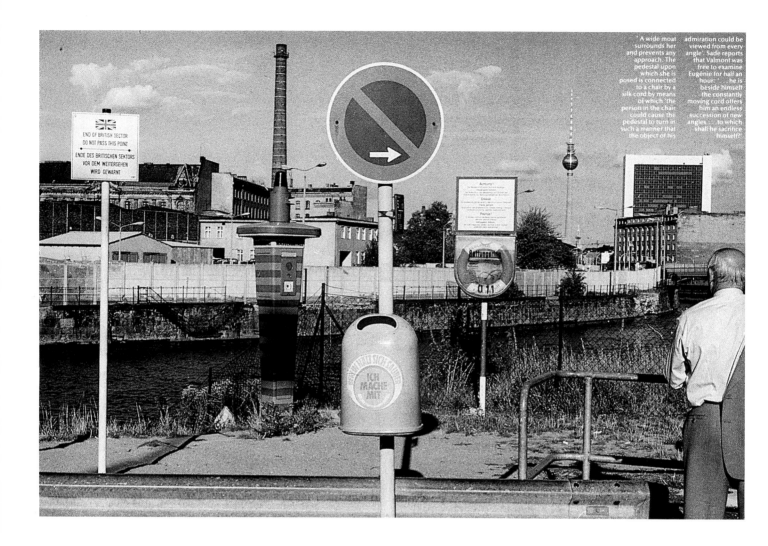

' A wide moat surrounds her and prevents any approach. The pedestal upon which she is posed is connected to a chair by a silk cord by means of which 'the person in the chair could cause the pedestal to turn in such a manner that the object of his admiration could be viewed from every angle'. Sade reports that Valmont was free to examine Eugénie for half an hour: ' . . . he is beside himself the constantly moving cord offers him an endless succession of new angles . . . to which shall he sacrifice himself?'

*How did it come about that your most recent piece was made in Berlin? Why have you called it* Zoo*?*

I was offered a DAAD, German Government, fellowship which would have allowed me to stay in Berlin for a year. As things turned out I was only able to stay there for about six months altogether. This isn't a work about Berlin in any documentary sort of way, that would have been arrogant, I don't speak German and haven't lived in Germany for any length of time. This is rather a work about the Berlin everyone knows, even though they may never have been there: the Berlin of the Wall, enclosure, isolation; the Berlin of the 1920s, with its reputation for 'decadence', the sexuality, its cosmopolitan character. I wanted both these aspects of the popular imaginary to be engaged in the work. I wasn't dealing with the real city so much as the 'city of the mind'. The 1920s are taken up through references to Viktor Shklovsky's *Zoo, or letters not about love* (Cornell 1971) which he wrote while in exile from Russia, in Berlin, in 1923. It was a book I was already familiar with; I first read it while I was living in New York, and enjoyed re-reading it in Berlin. As for the idea of enclosure, I found when I got to Berlin that the centre, where the main railway-station is, is called 'Zoo' — Zoologischer Garten — the actual zoo is right alongside the station — and all around the same area are sex shows called 'peep-shows', where a naked girl dances on a small revolving stage with booths all around it which you can enter and, by putting a coin in a slot, get a peep at the girl. Of course, not so far away there's the Wall with men peeping through slits in concrete boxes. I was interested in the possible links between these different forms of surveillance. If we turn to psychoanalysis we find that Freud's discussion of voyeurism links it with sadism — the 'drive to master' is a component of scopophilia (sexually based pleasure in looking); this *look* is a mastering, sexually gratifying look, and the main object of this look in our society is the woman. So, in this work, I'm taking the oppressive surveillance of woman in our society as the most visible, socially sanctioned form of the more covert surveillance of society-in-general by the agencies of the state. The text over this photograph describes the structure of the Panopticon prison — this is a prison where all the inmates can be watched from a single central tower, and it's the building Foucault has used as a metaphor for our contemporary forms of society-under-surveillance.

*Yes, in the piece you refer to we see the naked woman surrounded by the booths. The accompanying right-hand image is of a petty bourgeois painting of the Brandenburg gate hanging upon heavily patterned wallpaper.*

It's a picture of the gate *before* the war, of course. This image of

the old, undivided Berlin, I believe, is very much prevalent in the Berliner imagery. It's inscribed in the fabric of the city, in all sorts of ways: for example, many roads have been left running straight into the Wall, often with a decaying sign from the immediate post-war period, telling you are leaving the American, or English, or French sector. It's a way of treating the division of Berlin, and so of Germany as a whole, as a purely temporary aberration. This painting hanging in a café can be seen as contributing to this pervasive disavowal of the real situation.

*How does this connect with the image on the left?*

At one level, the connection is made through the idea of the viewer looking at a scene through an aperture. The photograph opens up a 'hole' in the gallery wall: on the left this opening coincides with the opening in the side of the booth; on the right the opening allows us a view of the wall of the café, but a further 'hole' has been made in this wall by the painting. The idea of framing we talked about before is being taken up again, but in a different way. This time it's a matter of the frame as an aid to *looking* — as a scopophilic device, like a keyhole. Then there are subsidiary points of correspondence internal to the scenes which are framed: the apertures of the gate look upon the ellipse of the pool with its central fountain; the apertures of the booths look onto the ellipse of the stage with its central woman. These, if you like, are the 'formal' connections — although it's more than just a matter of visual design. Now there are other connections which are more on the side of 'content', more to do with the overall themes of the piece, and which are based on contrast as much as on similarity. Both the woman and the gate are, in a manner of speaking, objects of desire, but one object is cast within the discourse of sexuality while the other is cast in the discourse of politics and of history.

*When you first showed me this piece I ignored all this about Berlin and constructed the 'meaning' of the piece from the ways in which, firstly, the naked woman and, secondly, both this kind of painting and wallpaper are looked at in our society. There is a very real way in which the 'woman' in pornography, women in the media generally — think of Legs and Co. — are a kind of wallpaper: pin-ups are actually used as wallpaper. Wallpaper with its patterning, its formalised drawing and its repeats, is very much a product of that mastering look we talked of earlier, that drive to control — albeit the world of appearances is 'mastered' by the most banal of techniques. However, this only goes to demonstrate the extent of cultural resonances of the particular piece. Could you explain further what you mean by saying the gate is 'desired' — a lot of people probably find that a bit strange.*

Let me first say what I *don't* mean. I'm not saying anything

like: 'Gates are apertures to be penetrated and therefore they're sexual objects'; obviously such configurations *can* lend themselves to sexual symbolisation, but the statement as it stands is the worst sort of vulgar-Freudianism. It's not a matter of gates in general, but of one gate in particular — the Brandenburg Gate — in a particular place, Berlin, and at a particular time in German history.

*In this particular connection then . . . ?*

I'm using the term 'desire' in its psychoanalytic sense. Freud actually uses the German words *Wunsch* and *Lust*, which correspond more or less to the ideas connected to the English 'wish' and 'sexual desire', although *Lust* can be translated as 'pleasure'. French psychoanalysis uses the single term *désir* and it's by this route that the term has recently come into circulation in psychoanalytic literature in English; specifically, in its definition in relation to 'need' and 'demand' in Lacan. But without going into the 'small print' we can get a general idea of the sort of meanings circulating around the term 'desire' if we keep in mind the 'wish' end of the scale as much as the 'lust' end. The psychoanalytic 'wish' is always bound up with some sort of elementary image-trace derived from the earliest registered infantile experience. In a very crude analogy, we can think of objects of desire as the distorted reflection, in a rear-view mirror, of things which lie behind us. The more desire presses forward the more, in a sense, it leaves its object behind. There's a sense in which all desire is desire for the past: for the individual's lost infantile sense of completeness, of plenitude. This idea of the lost object, the thing we need to complete ourselves, the 'lack' in our being, but from which we're irretrievably separated, is inscribed across the entire city of Berlin; the city can easily serve as a general metaphor for the various aspects of what psychoanalytic theory likes to call the 'splitting of the subject' — the division of Berlin and its lost objects, e.g. the gate. The pre-war gate is 'desired' in so far as it promises to fill a lack in modern Berlin, but I'd stress that I'm speaking *strictly* at the level of metaphor and analogy.

*I suspect some of our readers will be grumping at this point that it's come to a pretty pass if you need to know all this to approach the work.*

It would be if you did, but you don't. For example, I can enjoy Seurat's *La Grande Jatte* without sharing Seurat's enthusiasm for optical physics. Nevertheless, arguably, if Seurat hadn't had that interest in the theory then we wouldn't have had that form of painting practice we call *pointillism*. The painting, we might judge today, has very little to do with optics, but it has a lot to do with Seurat's *interest* in optics. Or, to give another example, you can enjoy Sartre's novels without having read his philosophical

work. I mean the technical work like *Being and Nothingness;* even though, effectively, his novels are the continuation of philosophy by other means.

*I'm still not sure I'm convinced.*

Let me make another point, which I think is more conclusive. There can never be any question of simply and finally 'understanding the meaning' of the work. The meaning isn't 'in' the work, like a lump of cheese in a wrapper; nor is the meaning somehow 'behind' the work: in the mind of the author, for example, or in 'reality'. Meanings are the product of an individual's reading of the work and these readings in turn depend on that individual's particular biography and upon his or her social, cultural milieu. So it's always a question of a shifting plurality of meanings which vary 'within' the individual and between individuals. It's an enormously complex process. Now if I want to explain how I think certain psychoanalytic concepts can help us to understand better how this process works, in particular relation to photography, then I write a theoretical paper, or give a lecture, and in fact I *do* all of these things — but when I'm making 'art' I'm constructing an entirely different sort of text. There's a popular idea of art in which artists are seen as desperately trying to 'communicate' but, arguably, the texts of 'art' are those very texts most remote from a communicative intention. On the one hand there are fairly unambiguous and successful attempts to communicate — 'Walk/Don't Walk', for example; on the other end of the scale there are texts like *Finnegan's Wake.*

*Where would you place your own work on that scale?*

That varies between works.

*In fact the connection between text and image has become far less obvious in your recent pieces. The viewer is required to do far more work. Earlier you spoke of destroying the 'authorial presence' — often that strikes me as a weakness in some of the* US77 *panels which lack the directness of, for example, 'A Sense of Tradition' (in* UK76).

Much of that earlier work, from *UK76* back, was based on certain assumptions about the nature of ideology as 'false consciousness' we discussed previously — which no longer seem tenable. It's this which accounts for the heavily ironic tone of that work. I'm no longer happy with this as it positioned the reader as merely the *consumer* of my irony. In *US77* I used three distinct forms of language, one of which *did* demand more of the reader — made him or her more aware of having to *construct* meanings, rather than having just to consume them. What one ends up doing is not simply reading off the direct correspondences between the image and the text, but rather linking associations of the text to associations of the image — a

process, I suppose, closer to poetry, where meanings occur primarily along chains of associations.

*There is in poetry a dialogue, often, between the literal surface meaning and the meanings provoked by the associations attendant upon the words.*

Right. As I said, there are three kinds of 'voice' in *US77*: a didactic, maybe pedantic, voice; a narrative voice; and a paradoxical voice — let's say, for example, the sections, 'Omnimpotence', 'Framed' and 'Phallacy', respectively. In *Zoo* I've dropped the didactic voice for more or less the same reasons I dropped irony. I've also dropped the paradoxical form of address — the reason for this was that, although for a few people they were the more interesting texts, I found that most people had problems with it; well, that follows logically. But I do try to go for an optimum audience — I don't mean the *biggest* audience by any means, but it would be a big mistake to work only for a small number of theorists.

*Looking again at* Zoo, *what is this rather desolate looking photograph of?*

It's a derelict plot of land by Checkpoint Charlie. The Wall is behind you. The areas adjacent to the Wall are often barren and vacant. The exhibition referred to in the notice is one of the Wall: a documentation of its building and the attempts to cross it. The choice of image relates to the text which describes an actual event I witnessed.

*I find the text somehow incomplete.*

Deliberately so. The whole work is constructed to, if I can put it this way, 'foreground the lack' — that space we just talked about that is perpetually present and ahead, and which pulls desire after it.

INTERVIEW WITH TONY GODFREY, RECORDED IN 1979, PUBLISHED IN BLOCK 7, 1982

*Obviously, to go back over that interview, which took place three years ago, and ask questions at every point, would be impossibly lengthy. Having read it. though, there are a number of topics which, for me at least, call for further development. For example, I'm not certain how you would resolve the problem of gender position* vis-à-vis *the image; I'm also left wanting to ask you more about how you see your audience, particularly in view of the difficulty your work presents to many people; and I'd like to hear more about the problems of reconciling aesthetic pleasure and the political. Do you find that these are important questions, and if they are, can you give at least an outline response to them?*

They're important and *difficult* questions, there are no simple answers to any of them. They're also interrelated — a response in any one of the three 'areas' you've identified will have repercussions in the others. But anyhow, to begin with gender and looking: first, I'd say we can get nowhere with this question so long as we identify the categories of 'masculinity' and 'femininity', simply and unproblematically, with the biological gender of the viewer. The Freudian postulate of universal psychic bi-sexuality allows us to move beyond the fixed, blocked positions of biologism — where our investment in looking, our pleasure, would be seen as determined by gender — to consider a subjectivity which can take up positions, more or less freely, on either side of the divide of gender, or even on both sides simultaneously. This tourist (or even colonist) of a subject can be seen on the move in Freud's descriptions of phantasy-structures, where the subject can play any or all of the roles in the phantasy scenario. The subject here, of course, is *unconscious*, and pre-Oedipal — it takes no account of sexual difference; as adults in the social world we've had to take account of what we have between our legs. The most important question asked of any of us is asked the moment we have emerged from the womb: 'is it a boy or a girl?', the answer to that question precipitates us onto one or the other side of life's great two-lane highway, each strewn with its particular bits of historical debris (it's in this sense only that Freud meant: 'anatomy is destiny'). Our psychic make-up, our pleasure, is destined to have to take account of our sex, but 'take account of' is very far from 'determined by', and in its questing for pleasure the desiring subject will take advantage of the short-cuts of pre-Oedipal regression whenever they are offered. In this perspective therefore, we can accept that a woman can, and often does, take an active, voyeuristic, pleasure in looking at an image of another woman. The woman who takes up this 'masculine' position however is thrown into conflict — she feels she is colluding, *participating,* in the same process of objectification from which she herself *as social subject* suffers. (I'm not denying the perhaps more common narcissistic, identificatory, relation

— but there is conflict here too, although its 'modality' may be different.)

In responding to your first question, then, I'm led very easily to your third — the question of politics and pleasure; the link is the problem of the reconciliation of a bi-sexual unconscious with a mono-sexual body; (there are instantly problems of language: 'bi-sexual' referring to the oscillations of active/passive, the pre-Oedipal ignorance of sexual difference, Oedipal phantasies-of/identifications-with the other sex, and so on; 'mono-sexual' meaning simply the given biological gender). However, I should say I'm not really qualified to speak on what may be the most important issue here — that of a possible 'specificity' of representation *by* women in relation to the female body — as a man what can I possibly have to say? My interest in the theory, even, (the *pleasure* I take in it), will never be free of the element of voyeurism, always already constructed and in place. However, I can use the theory to gain a necessary distance on my *own* relation to representation. The man's relation to the whole problematic differs fundamentally from the woman's: the woman must, by discovery and invention, locate herself-for-herself in representation where now, predominantly, she takes place only for men; the man, on the other hand, is everywhere in representation in his own interest, and his interest seems predominantly to allay his castration anxiety — I'm aware this sounds reductionist (I'm invoking Freud, not Lacan — I mean the *organ*) but I believe it's true. Along with all other men in this society at this time my relation to representation is fundamentally *certain* (where the woman's is always precarious), and fundamentally fetishistic. That's the bad news; the good news is that I *know* it, and may therefore be able to do something about it. We can't dispense with the phantasmatic relation to representation, but we should be able to re-work it, restructure it. The possibility for this lies precisely in the fact of the *shared* pre-Oedipal sexuality of men and women, the recognition of sexuality as a *construct,* subject to social and historical change; and the recognition of the body as not simply given, as essence, in nature, but as constantly reproduced, 'revised', in discourse.

What are the specific terms of change, of politics, in representation? In the 1970s, the preliminary attention was to 'images of women' — the 'stereotype', conceived of as an *image fixe*. This was, and still is, a necessary attention, but it can't be sufficient; the facts of representation/sexuality don't just concern the *item*, the 'iconogram', the facts are *articulated* — we're dealing with a *rhetoric* of sexuality; a rhetoric, moreover, embedded in, encountered in terms of, the entire social system (intertextual, institutional — *discursive*). These structures have 'objective'

manifestations — divisions of domestic labour, for example — which are the sites, and stakes, of political struggle. The structures, in the register of the *psychic*, take on subjective phantasmatic forms. Now political struggle in the *objective*, pragmatic, empirical realm, may be *re-presented* in forms of propaganda and agitation. These forms in turn may be sited in the art institutional spaces — galleries, art books and magazines. Fine, to the extent that this helps the original struggle on whose behalf it speaks. But let's not believe that such work touches upon representation itself in any but the most accidental and superficial of ways. What such strategies too often devolve into is what I would characterise as 'Left Kitsch' — the OK 'issues' of the day (nuclear disarmament, domestic labour, or whatever) dressed up in the OK 'artistic' form of the day (which can be anything at all, from photo-montage to 'punk painting').

What I'm urging here is that we distinguish between the *representation of politics* and the *politics of representation.* It ought to be clear that my own work is on the latter side, it's obvious that my orientation is theoretical rather than pragmatic. I'm not much interested, *in my own work*, in the representation of politics (and I'm really tired of being criticised for 'failing' in something I never set out to do in the first place). A politics of representation has to be concerned with the phantasmatic — this can't in any way (shock-horror) be considered a concern secondary to the political issues of the day, the fetishised 'real struggles', conflicts which renew and repeat themselves endlessly precisely to the extent that the phantasmatic which informs them, the imaginary in which they are situated, remains untouched by them. We don't *simply* inhabit a material reality, we simultaneously inhabit a psychic reality — the former, in fact, being 'known' only *via* the latter. Psychic reality, the register of the subjective, of emotion (including, of course, pleasure), is organised according to the articulation of sexual difference. What the women's movements have done in this century is to bring to light a repressed fact of history: there can be no basic social change of any permanence without a restructuring of the perception of the consequences of sexual difference. The precise terms of this insight are not fully understood — which is why it's still at the centre of a considerable effort in theory and practice at this moment.

In speaking this way I'm aware that I've arrived at your second question, that of audience. By definition, the unconscious is that which is *resisted*. Of all the contributions to knowledge which are modern, those of psychoanalysis have to be argued 'from scratch' in each new generation. I see this every year in teaching: I'm sure no student would

hesitate for a moment in accepting the world-view of sub-atomic physics, but the recognition of the banal and everyday fact of the unconscious is achieved by only a few, and then with some struggle. Any form of cultural production — theory or practice — which openly forms an alliance with psychoanalysis is going to be viewed with suspicion, or outright hostility. (I'm referring of course to that which is radical in psychoanalysis, and not to the many revisions of Freud in the direction of mysticism, humanism and biologism.) This observation brings me right to the point: the question of audience has to be framed as a question of *discourse*, of 'discursive community'. We have to abandon that ideological set-piece which aligns the 'audience' problematic along the divisions of consumer/producer, passive/active, collapsing all considerations into the moralism of 'individual responsibility', the artist's responsibility to reach a large audience, the artist's responsibility not to compromise for the sake of popularity — the tedious pseudo-debate of populism v. elitism which has got absolutely nowhere since the arts and crafts debates of the nineteenth century. My work is produced out of and into an extant discursive community based in politics, semiotics, and psychoanalysis. The content of the work, again, is in line with that community's interest in questions of ideology. My *practical* problem is that the community of real individuals corresponding to the discursive formation here overlaps only very slightly with the 'art community' — but this is an inevitable, unavoidable, problem. In the interview I spoke of seeing my work in terms of a number of different activities within the art institution as a whole — not the least of which, as far as I'm concerned, is teaching. I spoke of the need to shift the discourse of the institution: that is to say that it's important to see the institution not only as a number of (often literally) *concrete* manifestations (like the Hayward Gallery), but also as a specific discursive formation. The idea of 'working outside the institution' tends to be taken only *literally*, as a call to take to the streets, but it must be more radically understood as a call to change the complex of ideologies, discourses, which dominate this particular subsidiary of the culture industry, and link it seamlessly with corporate capitalism as a whole. Working outside the dominant discursive formation of an institution *is* 'working outside the institution', and in the most fundamental way.

The 'audience' is always phantasmatic, in the sense that we can never know an audience in the form of actual *individuals*, 'real people' — audiences are always *projected*. An appeal-court judge on TV the other night said he kept in touch with public opinion by reading the daily newspapers, and adjusted his judgements accordingly — a sobering thought. I suspect this

way of forming a picture of an audience is the dominant one, however, and more or less justified in anything other than a judicial context. In the interview, I talked about the journals I read (*Block*, I hasten to say, hadn't appeared at that time); the 'art audience' is defined in terms of a very different set of journals — this pre-supposed readership is clearly inscribed across, for example, most of the exhibitions which are made in this country. The interview closed with a reference to the 1979 *Three Perspectives* show — the response to that exhibition from the art journals and 'quality' newspapers was almost universally hostile; the attendance figures however were well above average for Hayward Gallery exhibitions. Similarly, the recent B2 exhibition of 'difficult' image-text work by five women artists was extremely well attended, but I would be very surprised to hear that it got more than a passing mention in the established art press. The question of audience is under-theorised precisely to the extent that humanist moralism has succeeded in making it a personal question — it isn't, it's *political*, the specific form of politics here being a politics of discourses in conflict on a given institutional site.

REPONSE TO QUESTION BY JOHN BIRD, BLOCK 7, 1972

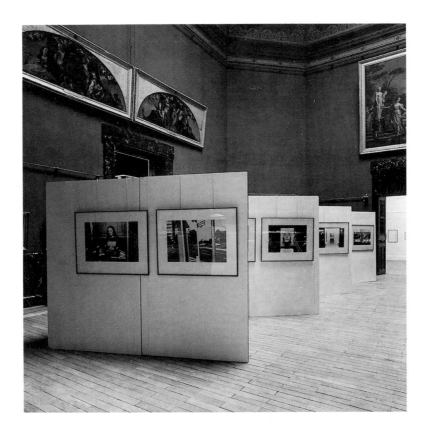

# I n L y o n

THREE TRIPTYCHS, EACH PANEL 20 x 26 INCHES, 1980

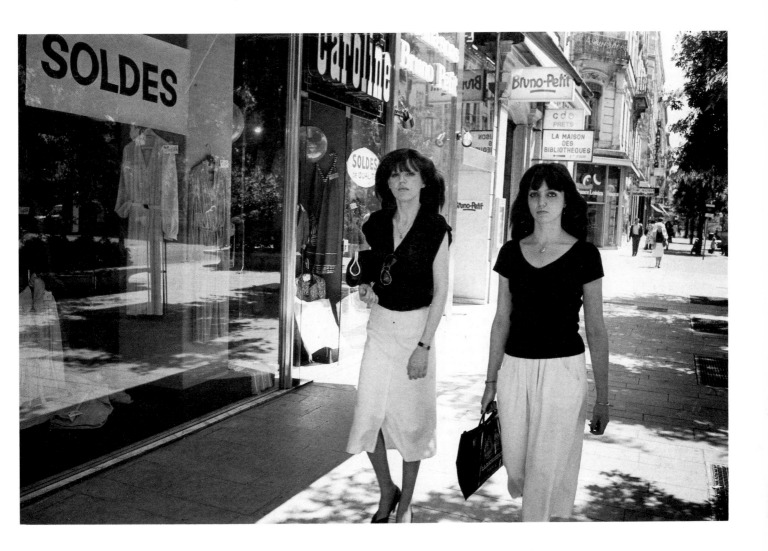

For many years she had worked for a large business concern. She lived quietly with her mother and there had been no man in her life until, recently, she had responded to the attentions of a colleague. One afternoon in his apartment, in the midst of their embraces, she was startled by a sharp sound, a kind of 'click' which seemed to come from the balcony. She became increasingly convinced that the noise she had heard had been the sound of a camera shutter, and that her lover had conspired to have her photographed in a compromising situation. She confronted her lover. He could not convince her that her suspicions were unfounded.

Those suffering from paranoia are struggling against an intensification of their homosexual tendencies. The persecutor is at bottom someone whom the patient loves or has loved in the past. The idea 'I (a man) love that man', if unacceptable to consciousness, is rejected through the inversion, 'I hate that man'; which in its paranoic form becomes, 'That man hates me.' Thus the persecutor must be of the same sex as the person persecuted. But this present case seems to contradict this thesis. The woman seems to be defending herself against love for a man by directly transforming him into a persecutor. There seems to be no trace of a struggle against a homosexual attachment.

Following the death of Julius Caesar the Roman Senate, fearing that Caesar's former lieutenant Lucius Munatius Plancus might combine his own troops with those of the mutinying Marc Antony, ordered him to build a city at the confluence of the Saône and the Rhône.

It emerged that she had visited the young man's apartment not once but twice. Nothing unusual occurred during her first visit, but she reported an event of the following day. Her lover had appeared in her office to discuss some business matter with her superior, a woman with whom she was a favourite and whom she described as being "grey-haired, like my mother". She became convinced that the two were talking about her, and that her lover and her superior had for some long time been having an affair to which she herself had been but a marginal diversion.

We may now see the grey-haired superior is a substitute for the mother, and that in spite of his youth the lover has been put in the place of the father. The original persecutor is thus the mother, love for whom arouses all those tendencies which play the part of 'conscience', and seek to arrest a girl's first steps towards her sexual liberty. The lover has become the persecutor only indirectly, through his 'conspiracy' with the substitute mother.

1336. Thousands had struggled, for more than a hundred years, in thousands of towns, to wrest from fuedal lords and clergy the right to assemble, to elect their own chiefs, to be judged fairly, and to protect their homes; thousands of small and obscure revolts which together made a great revolution. Here, a ceremony on an island in the Saône marked the entry into political life of those who were neither clergy nor nobility; the birth of a new class, the urban bourgeoisie.

*The affair was now over. Nothing could convince her on the question of that sudden noise which had so disquieted her. He denied even having heard it. He said he could only suppose that the sound must have come from a small clock on the desk by the window. She herself was convinced that no-one could have failed to hear that noise which to her had been so completely distinct.*

*I do not believe that the clock ticked, or that there was any other such noise to be heard. Her situation justified the sensation of an isolated contraction of the clitoris. It is the memory of this contraction, with all its attendant anxiety, which she projected in the form of her phantasised memory of the 'click'. Further, such noises are an indispensable part of the 'primal phantasy' of sexual intercourse between the parents, reproducing the sound by which the listening or watching child fears to betray itself. All is now clear: the woman's lover had become her father and she herself had taken the mother's place. The woman had allotted the part of the hidden spy to a third person: the 'photographer'. But the spy on the balcony is none other than the woman herself, as a child.*

*From the end of the nineteenth century, Lyon moved to the political rhythm of the country at large. During the First World War the working population of Lyon quadrupled and drew a female labour-force into the garment industries and into metallurgy, which in turn led to a transformation of attitudes amongst and towards women. During the Second World War, at the time of the occupation of France north of the Loire, Lyon became the capital of the Resistance. In 1944 there were expropriated certain major industrialists who, with the exception of Henri Lumière, had accommodated themselves to fascism. Since the war, commerce, older than industry, came to play the major role in the Lyonnais economy; today, more than 50 per cent of the active Lyonnais population work in commerce. Situated at the geographical intersection of several axes, the city is at the centre of a network of essential lines of communication. Lyon is a crucial and sensitive centre in the nervous system of the country.*

"Thank you for your letter. I'm sure you appreciate that if I could "explain" my work "in a few words" then there would be very little reason for me to *make* it. I can however give some sample indications of how it is put together — a sort of 'guide'. As with any guide, it selectively extracts 'points of interest' from a continuum of facts; and obviously, as with any guide, it is not intended to replace the thing it describes.

"*In Lyon* (1980) is composed of nine panels, arranged as three triptychs. The final section of each triptych is a panel of text, the preceding two sections are photographic images. Each of the three panels of text consists of three paragraphs, each paragraph is a fragment of a different discourse: narrative, psychoanalytic, and historical. Each of the photographs is of a part of the city of Lyon.

"The consistently tripartite structure of the work 'maps' the basic geographical structure of the city: built where two rivers meet, Lyon is in effect divided into three parts. Moreover, the most salient architectural features of the city commemorate three distinctive moments in its history: the extensive excavations of Roman buildings (Fourvière); the even more extensively preserved Medieval and Renaissance quarter (Vieux Lyon); and the aggressively 'contemporary' commercial centre (Part-Dieu).

"The narrative, and the psychoanalytic commentary on it, are both derived from a paper by Freud — 'A Case of Paranoia Running Counter to the Psychoanalytic Theory of the Disease' (*Standard Edition*, XIV, pp.261-72; 'Mitteilung Eines Der Psychoanalytischen Theorie Widersprechenden Falles Von Paranoia', *Gesammelte Werke*, X, pp.234-46). The paper has been rewritten and condensed, with some alteration of detail, to allow narrative and commentary to proceed in parallel and in three distinct 'moments'. The historical discourse is derived from a history of Lyon, and proceeds according to the Roman, Medieval/Renaissance, Modern stages referred to above.

"Triptych 1: The first photograph in the first triptych is composed by analogy with the plan of Lyon, with its two confluent rivers. Of these two rivers, one — Le Rhône — is 'masculine', while the other — La Saône — is 'feminine'. The protagonists in the narrative are a man and a woman. The second photograph shows two women. Added to the 'woman' (statue) already given by the first photograph this gives *three* women — corresponding to the 'three women in one' of the female protagonist in the narrative (Adult: the actual woman having the affair. Child: this same woman as a child, projected in the form of the 'spy'. Mother: the woman's own mother, both introjected in the form of a censorious super-ego, and then

projected in the form of the office superior).

"Triptych 2: The first photograph shows a corner of the Roman site at Fourvière, flanked by a block of modern apartments with balconies (a balcony features importantly in the narrative; balconies are also to be seen in the first photograph of triptych 1). The compositional device of the rail divides the photograph down the centre: to the left is the 'past', to the right is the 'present'; to the left there are 'stone' leaves, to the right are 'living' leaves (what are also present here, of course, are three generations of traces: actual, carved, photographed). The second photograph shows the commercial centre of Part-Dieu, its relations to the first image are predominantly formal: the metal tubing in both images; the overlapping, open, rectangles; the patterns of windows and brickwork; the patterns of paving. The 'three women' motif is also repeated here in the form of the two actual women — striding forward — together with the 'striding' sculpture (sculpture-statue-woman).

"Triptych 3: The first photograph shows the cathedral at Fourvière — erected in the nineteenth century as an expression of thanks to the Virgin that the Prussian invasion of France had halted short of Lyon. The communications tower beyond makes a similarly literal reference to some of the contents of the final paragraph of the history discourse. The statue at the left of the frame is one of a pair of winged lions at the entrance to the cathedral ('literalisations' of the city's name), but deprived, by the framing, of its head it could equally well suggest a Sphinx (the 'puzzled' Angel). The second photograph, the final image in the series, is even more open and ambivalent — fragments of bodies at a bus-stop. The final two images are to, in a sense, 'contradict' the closure and resolution of the narrative and its interpretation: the history of the subject, like the political history given in the text, proceeds through struggle and remains perpetually incomplete.

"What I have given above are simply points of departure for associative thought, which are also points of correspondence across the work. I see the work as a whole as a condensation of a complex of images/ideas centred around the imbrication of the psychic and the social, of sexuality and politics. The processes of reading the work ('unpacking' the condensations) I have indicated as primarily metaphorical and metonymical (they are, in totality, the 'primary processes' of the unconscious as exemplified in Freud's description of the *dream-work*)."

I'D STARTED TO LOOK OUT FOR MOTHER-DAUGHTER COUPLES
to photograph — without too much enthusiasm, because I really felt that
such an image would be too literal, too much an *illustration* of the text. Then I
noticed that, in the streets of Lyon, there were women who would go around
together *dressed* similarly. This image seemed more interesting, less closed to
interpretation, and more broadly suggestive of such themes as 'identification'
and 'introjection'. I came across one pair of young women who were dressed
not just similarly, but *identically*. I tried to photograph them unawares, using
all the subterfuges of classic, covert, 'street photography'. But something
always happened at the moment I took the picture, some extraneous person
would walk into the frame, or one of the women would shoot off at a tangent
to look in a shop window. Then, quite suddenly, I became self-conscious — I
*saw* myself watching them. It was as if I'd disturbed myself in an act of
voyeurism, and I felt embarrassed. No-one else seemed to have noticed me
taking the pictures, certainly the two women hadn't, but it was as if *I* had
noticed, for the first time. I thought, "this is crazy". I walked up to them,
introduced myself, and explained what I was doing, and I asked if they would

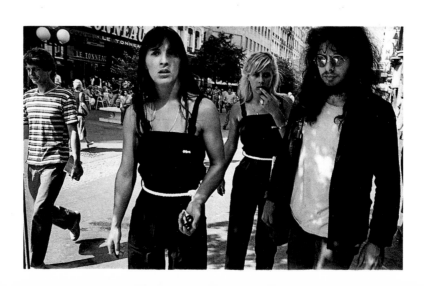

*mind* if I took their picture. They didn't. They obviously thought the whole thing was a giggle, and they very happily walked up and down the street for me while I took my shots. Of course, the pictures were terrible.

On what grounds do we judge a picture of this sort to be 'bad'? Apart from the usual sorts of aesthetic criteria, I think the *genre* of 'street photography' requires that nothing be staged. It's somehow acceptable to us that the models in a studio shot pose for the camera — even if this means their behaving as if they were ignorant of the camera — but this sort of conscious relation to the camera is unacceptable in what otherwise bears all the marks of being what was once referred to as 'candid' photography. Anyhow, whatever we may decide upon as the operative criteria, it was the moral aspect which presented itself to me most forcefully on that particular occasion. I realised then that to get 'good' pictures in the street — of this particular sort, where one has to intrude into a stranger's zone of intimacy, their personal 'three mile limit', as it were — I would have to accept not only the element of risk of confrontation, I would also have to accept a certain sense of moral degradation, even a certain 'silliness'. So just at the time when I was becoming reasonably competent in this area of photography — and I can assure the non-photographers here that it's not easy — just as I thought I was starting to get good at it, I stopped. I decided to photograph people only from a socially acceptable distance, a distance from which they appear simply as part of the landscape. I think the last such picture I took was, actually, of the mother-daughter in the work I made in Grenoble the following year. But it *was* the last, by that time I had become convinced that people should be allowed to go about their lives without being appropriated as camera fodder, from *whatever* distance.

The particular situation I've just described has, of course, *two* distinct aspects to it: it not only concerns individual rights to privacy from the camera in public places, it also concerns voyeurism. One of the defining attributes of the voyeuristic relation is that the one giving the look should be *concealed* from the one receiving it. In deciding to 'become visible' on that occasion, I suppose, I was trying to deal with the problem of how to 'speak' of voyeurism, in my work, without *behaving* as a voyeur. There's certainly no simple answer to this problem — one can be 'hidden' behind a battery of studio lights, or in the simple act of raising the camera and looking through its keyhole of a viewfinder. Perhaps it's a mistake to focus on the act of looking itself, an empty moralism simply to code voyeurism as 'bad'. Perhaps we should focus rather on the *relational* aspect of voyeurism — a relation which, according to individual cases, may, or may not, be oppressive.

FOLLOWING THE INVITATION TO MAKE A WORK IN LYON I WAS asked by the Museum of Painting and Sculpture in Grenoble to make a work which would establish a link between their seventeenth-century collection and the contemporary city of Grenoble. Grenoble had had a socialist administration for a great many years, and this administration's most ambitious project of urban renewal had been the building of what was in effect a satellite town on the periphery of the old city of Grenoble, called 'Villeneuve'. It's on a beautiful site, surrounded by mountains, carefully landscaped and provided with artificial lakes, with trees, open-air swimming pools, and so on. There's a mix of high and low-rise housing and a variety of rents. The project was intended mainly for the benefit of workers, but there were incentives to attract other economic classes to Villeneuve, and a very real attempt to have 'artists and intellectuals' living there. The new school of architecture was built as part of the Villeneuve complex, and architects involved in the design of Villeneuve were required to spend a period of time living there. In short, Villeneuve was to be a socialist Utopia — so for the point of departure for my work I decided to think in terms of the juxtaposition of this Utopia with another, the Claude landscape in the collection of the Museum.

There are two versions of *In Grenoble*. The original version has six images, two of which are different from the ones used in the New York version. The main difference is in the text and the overall intention. The text is straightforwardly 'denotational' — it was written in French, which for me is a code rather than a language. I have little appreciation of connotational subtleties in French. The work as a whole is socio-historical in its tone rather than psycho-historical, and I rely more on meanings which may be picked up by those with local knowledge. You could say the French version is easier to read.

LA JUXTAPOSITION DES ÉLÉMENTS
A DOMINÉ L'ESTHÉTIQUE MÉDIÉVALE:
UNE SUCCESSION DE FRAGMENTS,
UNIFIÉS DANS L'ENVIRONNEMENT
DE CROYANCES RELIGIEUSES.

PENDANT LE RÈGNE DE LOUIS XIV,
LE PAYSAGE CLASSIQUE SERT COMME MISE-EN-SCÈNE
DU POUVOIR MONARCHIQUE ABSOLU:
LOUIS DEVIENT APOLLON-LOUIS;
LE ROI-DIEU, LE ROI-SOLEIL.

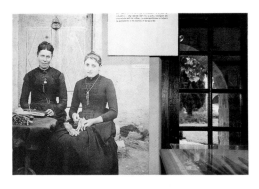

AU QUATTROCENTO, LA PERSPECTIVE
S'EST IMPOSÉE COMME RAPPORT INDIVIDUALISÉ
ENVERS UNE RÉALITÉ SÉCULAIRE, EXTÉRIEURE À L'OBSERVATEUR:
LES FRAGMENTS SONT CONDENSÉS EN UN TABLEAU,
UN ENSEMBLE PLACÉ DANS UN SEUL CADRE.

AU SEUIL DE LA SOCIÉTÉ INDUSTRIELLE,
DE TELLES REPRÉSENTATIONS-AU-POUVOIR
SONT RELIGIEUSES AU PREMIER SENS DU MOT, *RELIGARE* – RELIER;
PARCE QU'ELLES PERMETTENT AUX MEMBRES DE LA NATION
DE COMMUNIER DANS LE MÊME CADRE DE RÉFERENCES.

AU XVIIᵉ SIÈCLE, LE PAYSAGE CLASSIQUE EST NÉ
DU DÉSIR DE RECRÉER LE MONDE DÉCRIT PAR VIRGILE OU OVIDE:
LE PAYSAGE, ORNÉ D'ÉDIFICES ANTIQUES,
DEVIENT LE CADRE DE SCÈNES EMPRUNTÉES À LA MYTHOLOGIE
OU À L'HISTOIRE ANCIENNE.

AU PREMIER PLAN, UN RUISSEAU TRAVERSÉ PAR UN PONT RUSTIQUE;
À GAUCHE, DEUX PERSONNES; À DROITE, LES RUINES
DU TEMPLE DE LA SIBYLLE À TIVOLI.
PLUS LOIN, DES FABRIQUES.
AU FOND, UNE RIVIÈRE ET UN PONT.

# *In Grenoble*

ENGLISH VERSION, FIVE PANELS, EACH 20 x 24 INCHES, 1981

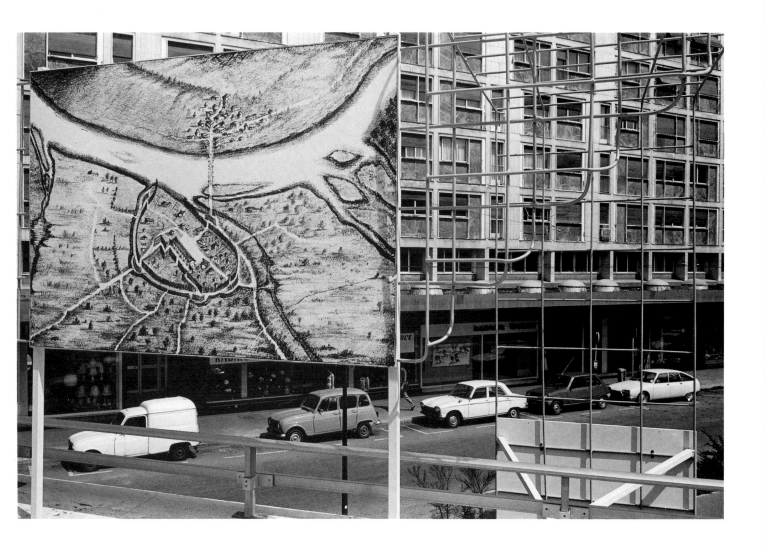

THE PLAN OF THE PLACE
WHERE I GREW UP
IS AN ANATOMICAL DRAWING.
THE THOUGHT OCCURS:
"THEY ARE FIGURES 1 AND 2".

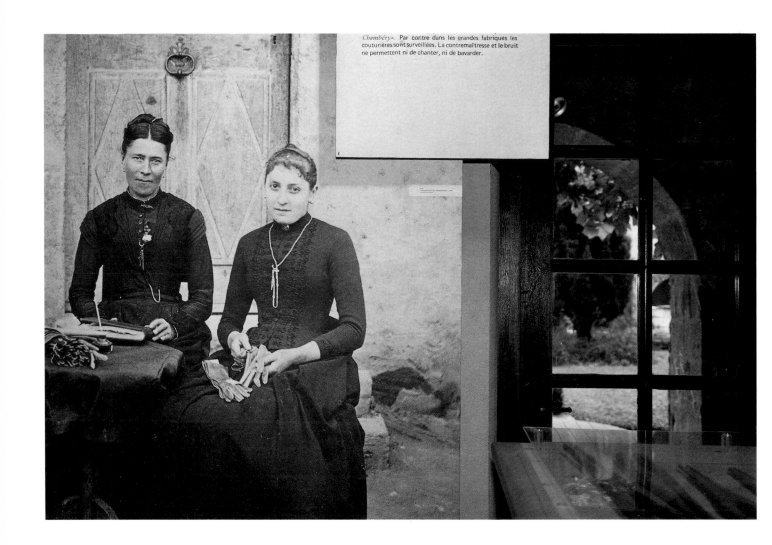

THE TWO FIGURES ARE MY MOTHER AND SISTER.
THEY CANNOT SPEAK AND I AM FORBIDDEN
TO SHAKE HANDS WITH THEM.
THE THOUGHT OCCURS:
"IT IS BECAUSE WE ARE IN THE BANK".

ON THE BANK TWO PEOPLE ARE MAKING MUSIC.
I CAN SEE THE BUILDING WHERE
MY SISTER AND I GREW UP.
THE THOUGHT OCCURS:
''I AM IN THE RIGHT''.

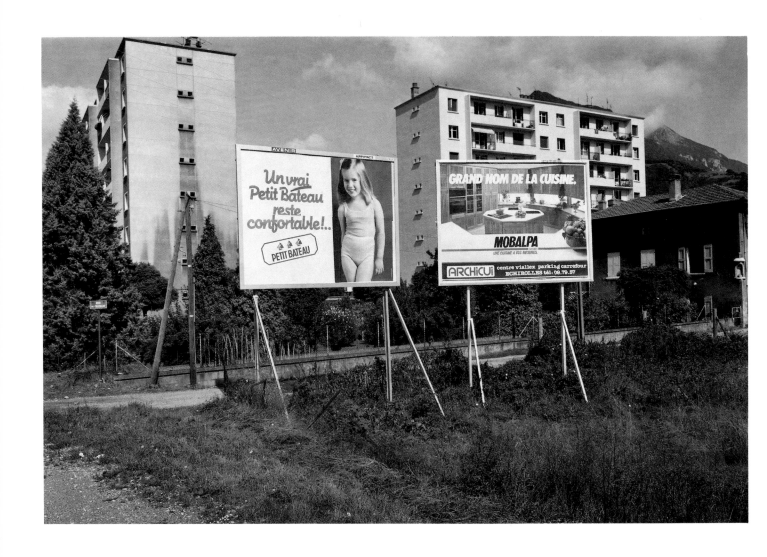

ON THE RIGHT THE BUILDING HAS A DISTINCTIVE FORM:
A CIRCLE FROM WHICH A SEGMENT HAS BEEN REMOVED
TO REVEAL AN INTERIOR SPACE CONTAINING SOMETHING.
THE THOUGHT OCCURS:
"IT WILL COME OUT IN MARCH"

THEY MARCH. A TREE STANDS AGAINST THE SKY.
A BRIDGE SPANS A RIVER. A BUILDING IS IN RUINS.
MY SISTER IS MY DAUGHTER.
THE THOUGHT OCCURS:
''ACCORDING TO PLAN''.

Chapter V, D, of *The Interpretation of Dreams* (*Standard Edition*, IV) contains the first description in Freud's work of the celebrated 'Oedipus Complex'. Chapter IV of this book contains the description of Freud's dream of 'Uncle Josef', in terms of manifest structure one of the simplest in the book: the first part of the dream is a thought, the second part an image. This structure only (now inverted) has been retained here to govern the form of the captions.

All the photographs were made in Grenoble.

The photographed text in the second image from the left reads: "On the other hand, in the large factories the seamstresses were under surveillance. The forewoman and the noise permitted neither singing nor conversation."

The third photograph from the left is of a landscape by Claude Gellée ('le Lorrain') in the Musée des Beaux-Arts, Grenoble. The ruined building depicted on the right is the Temple of the Sibyl, at Tivoli.

The final photograph is of the 'new' Grenoble — 'La Villeneuve' — now being constructed alongside the old.

THERE'S NO REAL *TRADITION* OF READING-HABITS APPROPRIATE TO
this sort of work. The modes of interpretation you learn as painters aren't
really very much help. For example, I wonder how many of you would spot
that the plan of the building described in this part of the text may be applied
to both the ruined temple in the Claude painting *and* to the 'dream-kitchen'
shown in that shot with the bill-board? Or even to what extent you will be
inclined to 'read' the final image in terms of the standard Claude elements
which can be found in this *particular* Claude — a tree silhouetted against the
sky, two figures, a ruined building, a place of passage in the foreground, misty
mountains in the background. OK, here in this image of Villeneuve the tree is
a struggling developer's 'pot-plant', and it has been transposed awkwardly to
the centre of the frame; the place of passage is no longer a bridge but a section
of pavement; the building is not ancient and half-ruined, but modern and
half-built; and so on. But such transformations and transpositions are
precisely the metaphorical and metonymical processes favoured by the
unconscious. You *don't* need a knowledge of psychoanalytic theory to deal
with work like this — you simply need to know how to dream. But perhaps
this 'dream-work' has become hard work to minds which, like our own, are
so much conditioned by the social imperative to rationality and *economic*
productivity. Perhaps we want merely to *relax* in front of an image, much as
we may 'relax in front of the television'. Perhaps we prefer to do our
'dreaming' in front of the Claude. I'll happily join you in this pleasure, and I'll
readily admit that I'm no Claude, but then neither are any of us burgers and
courtiers of the seventeenth century.

      I told you about the dream of 'Uncle Josef'. In the discussion
of this dream, Freud uses, as he uses again elsewhere, the example of Francis
Galton's composite photographs to convey the idea of 'condensation' in
dreams — Galton superimposed images of different members of a family in
order to bring out common features. The dream image of the face of Uncle
Josef is really 'one face seen in terms of another'. This is what I'm doing in
this piece — I'm seeing the Claude in terms of Grenoble, and Grenoble in
terms of the Claude, but both of these images have to pass through the prism
of my own history — which is a history of the construction of a 'masculine'
subject in terms of its putative opposition to the 'feminine', represented by
the body of the woman.

OVERLEAF, IN MALMÖ, ZG 1, 1981

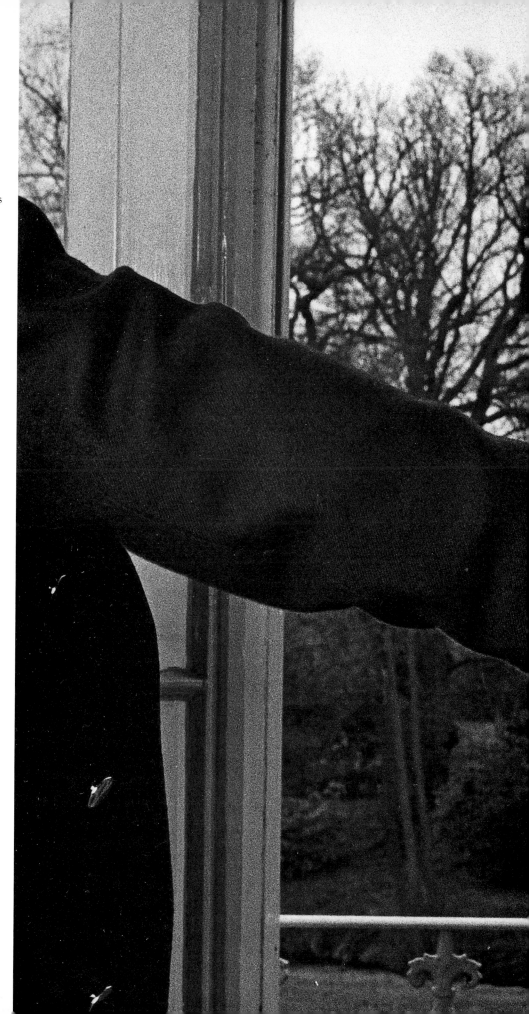

CERTAIN GESTURES can express
a whole social situation.
She is in a hotel room, watching TV.
He is talking about photography.
With only an instant at his disposal
the photographer must select
that moment which will yield
most meaning and pleasure.
Some social gestures may be
stopped in time
without losing their significance.
The result is a tableau
in which may be read
past, present and future.

SHE SAYS
the very division of space
into public and private places
is already
a significant social gesture.
Without the security of property
the liberty to walk the streets
is a freedom in the desert.
He says he doubts that an image
of an empty street
could communicate that idea,
any more than a photograph
of a factory could describe
the social relations of production.

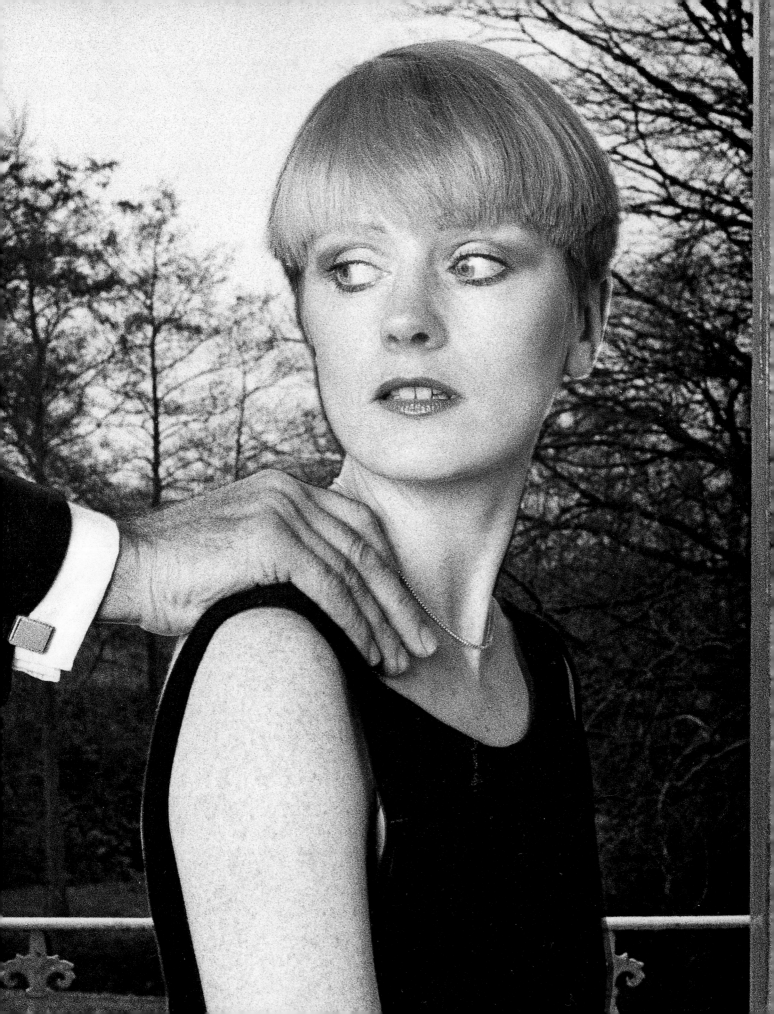

MALMÖ, SWEDEN, 1981

# Gradiva

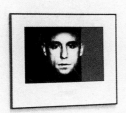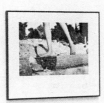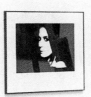

**SEVEN PANELS, EACH 20 x 24 INCHES, 1982**

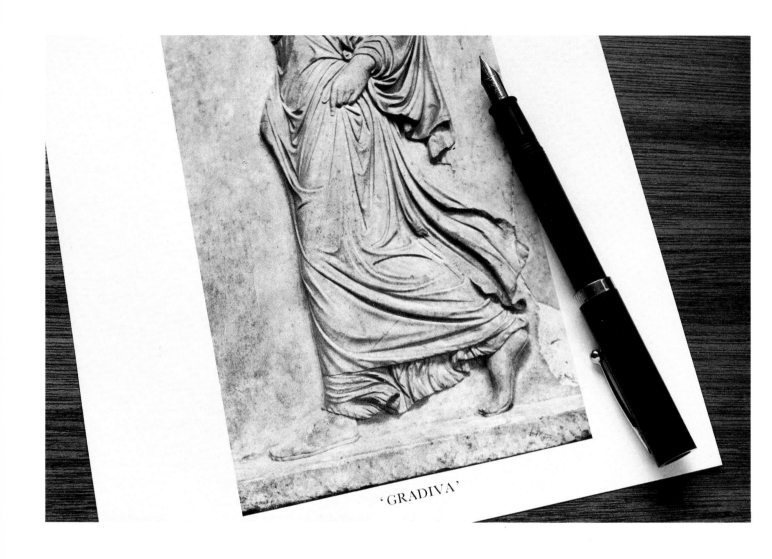

'GRADIVA'

SHE WAS RAISED
BY HER FATHER,
A DISTANT MAN,
FOREVER LOST
IN HIS WORK.

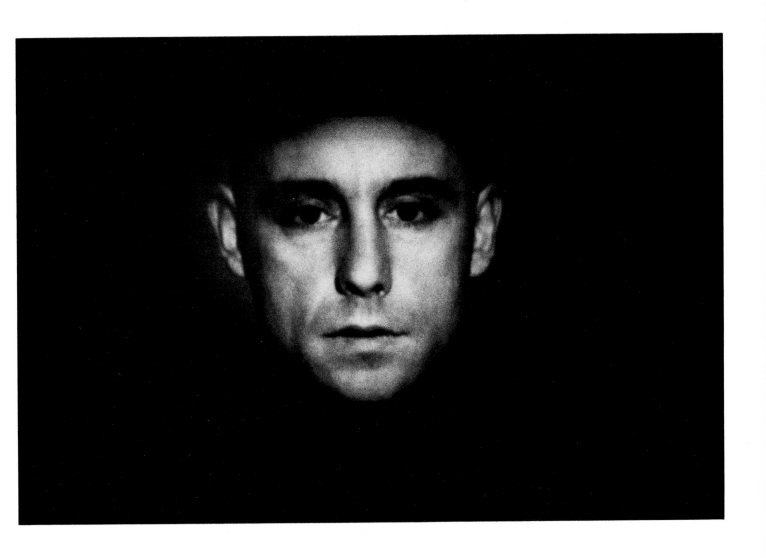

IN CHILDHOOD SHE FOUND COMPANIONSHIP
WITH A NEIGHBOUR'S BOY OF HER OWN AGE.
YEARS LATER, NOW ADULT, SHE ENCOUNTERED HIM AGAIN, BY CHANCE;
HE SHOWED NO SIGN OF HAVING RECOGNISED HER,
WHICH PLUNGED HER INTO DESPAIR.

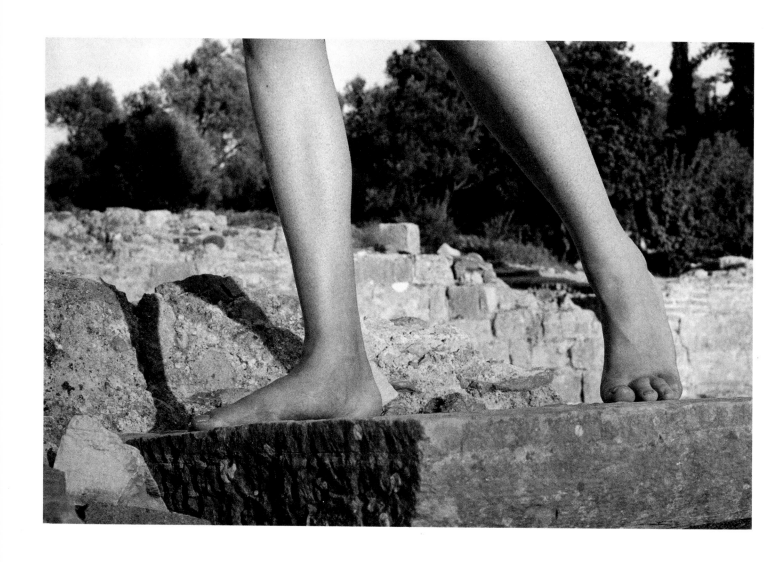

SHE COULD TAKE NO INTEREST IN ANY SUITOR.
SHE RESIGNED HERSELF
TO THE COMPANIONSHIP OF HER FATHER,
ACCOMPANYING HIM
ON HIS TRIPS ABROAD.

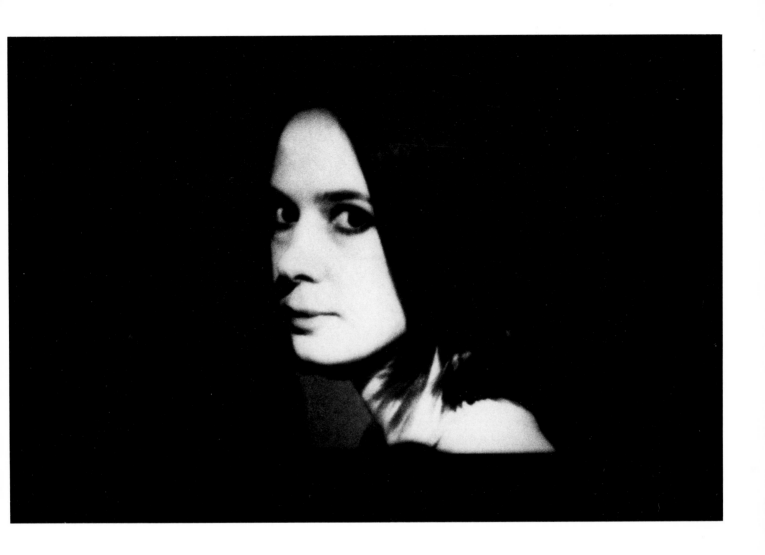

IT WAS WHILE SHE WAS VISITING
THE RUINS OF POMPEII
THAT SHE BECAME AWARE OF
THE FIGURE OF A MAN
WATCHING HER.

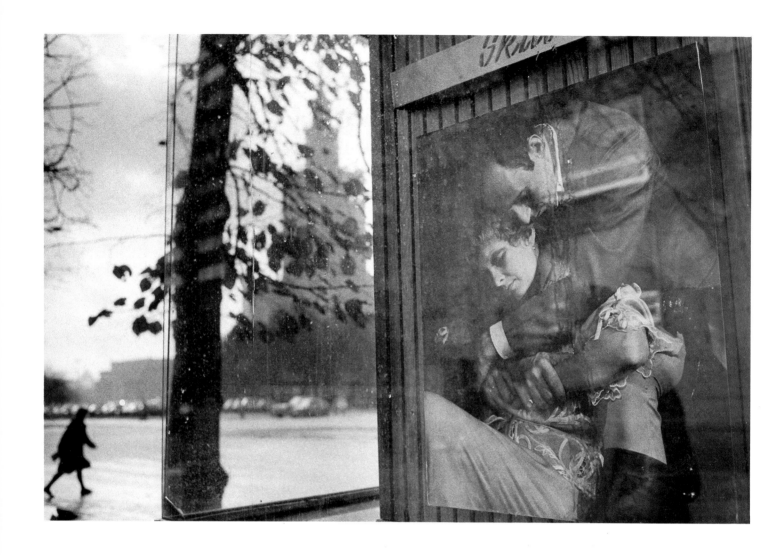

ALONE
IN THE RUINED STREETS
HE WAS STARTLED BY THE SUDDEN APPEARANCE OF
THE FIGURE OF A WOMAN
MOVING WITH GRADIVA'S UNMISTAKEABLE GAIT.

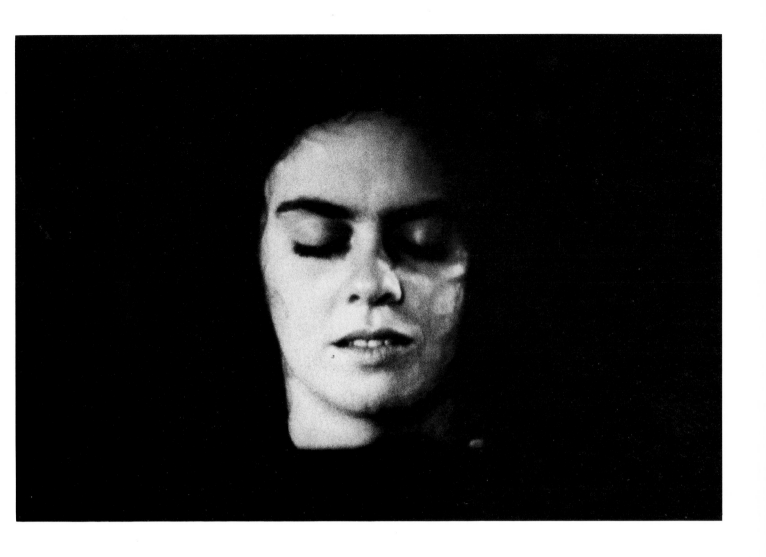

IN A DREAM OF THE DESTRUCTION OF POMPEII
HE BELIEVED HE SAW GRADIVA, AS IF TURNING TO MARBLE.
HE RESOLVED TO TRAVEL TO POMPEII
IN THE HOPE OF FINDING SOME TRACE OF
THE LONG-BURIED GIRL.

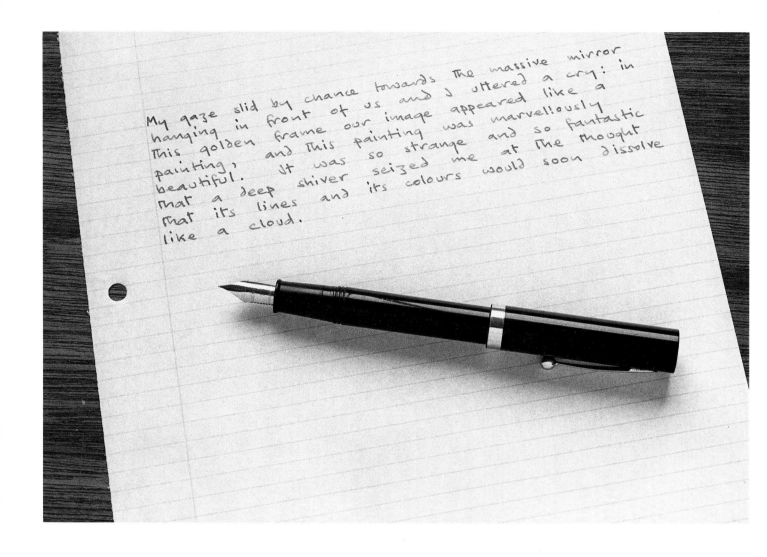

My gaze slid by chance towards the massive mirror
hanging in front of us and I uttered a cry: in
this golden frame our image appeared like a
painting, and this painting was marvellously
beautiful. It was so strange and so fantastic
that a deep shiver seized me at the thought
that its lines and its colours would soon dissolve
like a cloud.

THE RELIEF REPRESENTED A YOUNG WOMAN, STEPPING FORWARD.
ONE FOOT RESTED SQUARELY ON THE GROUND,
THE OTHER TOUCHED THE GROUND ONLY WITH THE TIPS OF THE TOES.
THIS POSTURE CAME TO HAUNT HIS THOUGHTS;
HE GAVE THE GIRL THE NAME 'GRADIVA' – 'SHE WHO STEPS ALONG'.

The text which parallels the images here is based on the short novel *Gradiva*, by Wilhelm Jensen; this story is the subject of a long article by Freud: 'Delusions and Dreams in Jensen's *Gradiva' (Standard Edition*, IX).

Photographs as follows:

1. The photograph 'quoted' here is of the frontispiece to volume IX of the *Standard Edition* cited above.
2. Image on a cinema screen, New York, 1977. Details of origin forgotten.
3. Roman amphitheatre; Gortys, Crete, 1981.
4. See 2, above.
5. Pl. Defilad, Warsaw, Poland; October, 1981. The building in the background is the Soviet-built *Palace of Culture and Science.*
6. See 2, above.
7. The writing is a quotation from Sacher-Masoch's *Venus in Furs.*

*GRADIVA* IS THE TITLE OF A NOVEL, PUBLISHED IN 1903, BY THE German writer Wilhelm Jensen, which Freud made the subject of a long essay — not because of its literary merit, Freud didn't think much of it as a piece of writing, but because of its interest to psychoanalysis. *Gradiva* is essentially a boy-meets-girl story. It tells of a young archaeologist, Norbert, who becomes obsessively fascinated by an antique relief of a woman stepping forward — the relief, as a matter of fact, is not at all fictional, it exists in the collection of the Vatican museum. Norbert becomes obsessed with the question of whether the woman's gait, the particular manner in which she steps out, could have been drawn from life or whether it was entirely the invention of the artist. In the grip of his obsession he finds himself watching women in the street for a trace of Gradiva's perambulatory style — but without success. As his obsession veers towards delirium his quest becomes a search for Gradiva herself, and he dreams that he sees her at the moment of her death, engulfed by the eruption of Vesuvius which destroys her home in Pompeii. Norbert travels to the ruins of Pompeii, where he enounters what, in his unhinged state of mind, he takes to be Gradiva's ghost. This 'ghost' turns out to be the young adult form of Norbert's long-lost childhood playmate, Zoe. Zoe, who has never stopped loving Norbert, recognises him right away. The rest of the tale is a story of how she gently coaxes him back to reality — for *he's* the one who has become 'not of this world'. Having regained his senses Norbert again falls madly in love with Zoe — who, of course, he had really loved all along in the form of his Gradiva delusion — and they live happily ever after.

The lives of these two young lovers, following their separation in childhood, form trajectories towards their encounter in the street in Pompeii. I was made to think of that much overdone scene from popular film and television romances where the lovers run towards each other from opposite sides of the frame — through a field, along a city street, or a beach — finally to throw themselves, as the orchestra whips itself into a frenzy, into each other's arms. I wanted to represent a situation in which the lovers run towards each other, and *miss* — like two express trains hurtling by on their separate tracks, towards their individual destinations. I was thinking of a celebrated and notorious remark made by Lacan in one of his seminars, he said: "Il n'y a pas de rapport sexuelle" — 'There *is* no sexual relation'. In an Egyptian myth, Isis and Osiris were once one, but a catastrophe split this 'one' into two beings — male and female — who were thereafter condemned to wander the earth in eternal search of reunion. There are other such myths. The lovers who crash together in modern soap operas are the descendents of this ancient quest for (re)unification: Mr and Ms Right come

together in perfect mutual complementarity. But what of the message in the myths — that (re)union is never achieved? I interpret Lacan's remark — 'there is no sexual relation' — to mean that the supposed relation of complementarity is a misrecognition of the fact that the only relation here is in fact with a *fantasy*. We project an image upon the other, and become in turn the screen upon which the other projects their fantasy upon us. It is in the gap between fantasy and reality that many such 'relationships' eventually founder. Jensen's story ends on a conventionally complacent note. I wanted to counter this by throwing Norbert's obsession with the relief *into* relief. Norbert's sexual relation is with an *image*, which prevents his establishing a relationship with the real Zoe. In the novel, Norbert's behaviour is seen as thoroughly abnormal, and he is subsequently shown as 'cured'. I wanted to imply that Norbert's behaviour is in fact a novelistic staging of what is perfectly *normal* masculine sexuality, and that there was therefore no real reason to suppose that Norbert was capable of spontaneously giving up this form of relation with his 'object'.

For this work I 'rewrote' Jensen's novel in the 'lapidary' form — a writing adapted to the needs of inscriptions on monuments, and to the stone-carver's art. Photographs of course are all, in a way, monuments to the past. I further rewrote the book in giving as much weight to Zoe's story as to Norbert's — the book is primarily about Norbert. I put Zoe's story first in terms of a conventional left-to-right reading. Norbert's story reads from right to left — from the final image towards the centre of the work as a whole. The central image is where the woman in the image turns to meet our gaze, where Zoe in the text turns to meet Norbert's gaze, and where the story pivots into Norbert's perspective. Up to this point you are given Zoe's point of view — you are drawn into her position in the written text, and you are given her position by the camera when you, as *viewer*, look at the face of the man who may represent Norbert. Once you begin, from the central image on, to see women in these dark close-ups, then you have stepped into Norbert's shoes. I've said the piece is composed to allow readings which proceed towards each other from left and right extremities — like the lovers moving towards each other along the paths of their lives, or from left and right of the cinematic frame. Of course it can also be read conventionally, from left *to* right, and in this reading you are brought full-circle back to the desk at which you began — along with Freud (who had daughters of his own) 'lost in his work'. (Incidentally, my own reading of *Gradiva* — concentrating as it does on fetishism and scopophilia — has little in common with Freud's reading of the book). Showing slides of the work, or even seeing it reproduced on successive

pages of a magazine, you lose some of the complexity of the readings which are encouraged when you see it 'in one piece', on the gallery wall. This form of visual art practice, to some extent, is analagous to pictographic, hieroglyphic, writing — which is not linear in the sense in which modern alphabetic writing is linear. Early alphabetic writing, for a while, retained some of this — early Greek and Latin characters had no fixed direction of reading and writing. If you take a conventional reading of this piece, then it's as if the narrative, as it progresses beyond the mid-point, 'meets itself coming back' in the opposite direction.

# *O l y m p i a*

  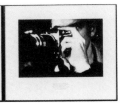   

TWO TRIPTYCHS, EACH PANEL 20 x 24 INCHES, 1982

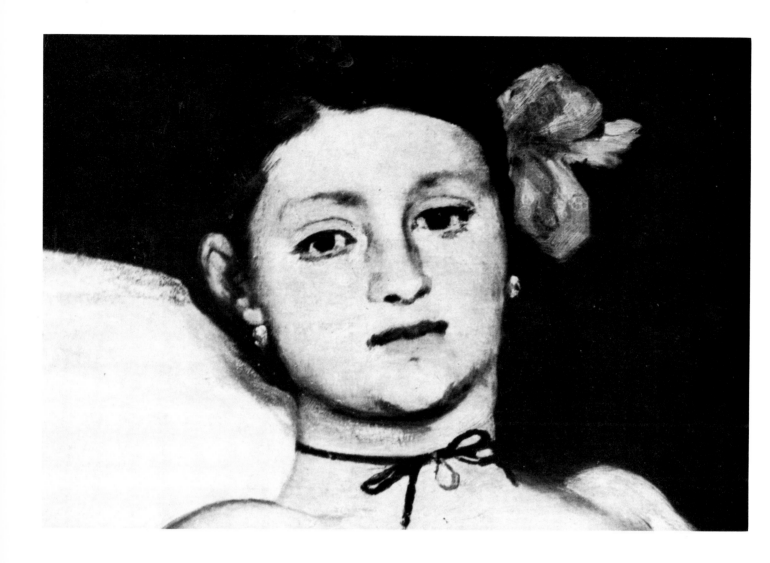

O. is a life-like doll, the creation of a brilliant professor.
Believing her to be real, a young student falls in love with her.
An intruder tries to steal the automaton, but is surprised by the professor.
A fight ensues in which the doll loses her enamelled eyes.
At that moment her admirer, sensing she is in danger,
bursts into the office.

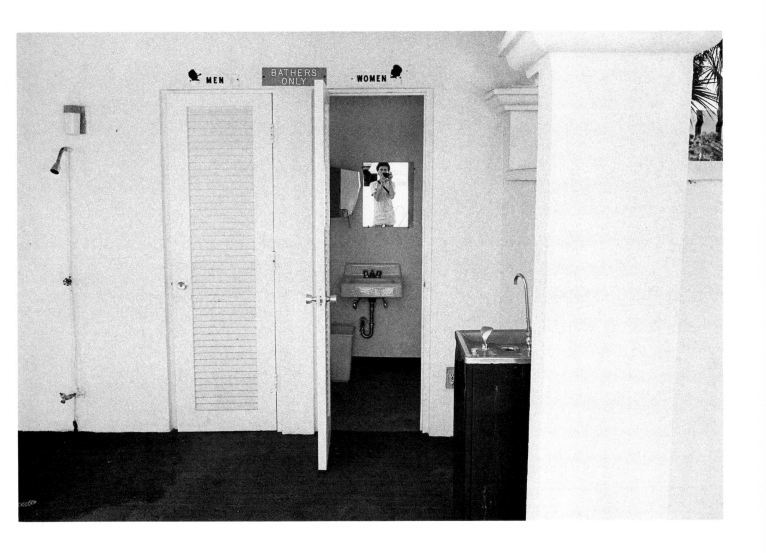

"Oh!"
(A door opens on a memory.)

Everything is petrified, frozen for all time, as I watch
the room in which she is to be seen sitting, motionless.
It seems she is staring in my direction,
although I cannot be certain. Sometimes her chair is empty,
but I continue to watch. It is as if the vacant room itself
returns my gaze, holding me spellbound.

O. is twenty-one, the patient of a brilliant professor.
Amongst her symptoms: all the people she sees seem like wax figures;
she knows she is wearing a brown dress but sees it as a blue one;
in a bunch of flowers she can only see one flower at a time.
A year now has passed since she was separated from her father
and had taken to her bed.

O.
(A story opens on a memory)

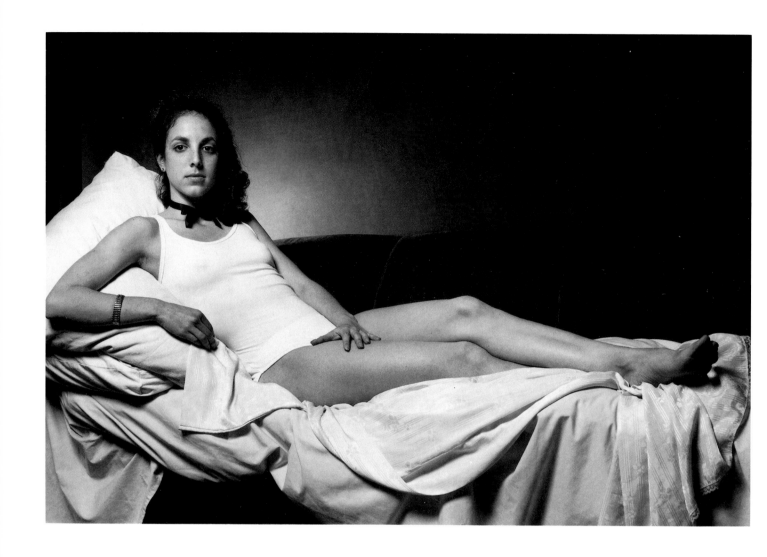

Everything shimmers, nothing is still, as I watch
the room in which my father lies.
It seems men and women are eyes and mouth,
although I cannot be certain; sometimes I cannot speak.
But I continue to tell stories. It is as if the vacant room itself
listens, holding me spellbound.

The mechanical doll and 'her' voyeur-admirer figure in E.T.A. Hoffman's 'The Sand-Man', discussed by Freud in 'The Uncanny' (*Standard Edition*, XVII). The origins of voyeurism are first discussed by Freud in 'Three Essays on the Theory of Sexuality' (*Standard Edition*, VII). These two texts are 'linked' here via the recollection of a story told by Lacan (see *Écrits*, Norton, New York, pp. 151–2).

Photographs:

1. *Olympia* (detail), Edouard Manet.
2. Siesta Key, Florida, 1980.
3. Image from *Rear Window*, Alfred Hitchcock, on the screen in a Paris cinémathèque, 1978.
4. Freud's study, 1938. Photograph by Edmund Engelman, from *Berggasse 19*, Basic Books, New York, 1976, plate 89.
5. See 1, above.
6. New York, 1982.

HOFFMAN'S STORY, 'THE SAND-MAN', FORMS THE BASIS OF THE
ballet *Coppelia*, and it also figures as one of the sections of the
nineteenth-century French operetta, *The Tales of Hoffman*. When, in 1881, *The
Tales of Hoffman* was first performed in Vienna, the theatre in which it was
being performed burned down, and 600 people died. The Emperor Franz
Josef subsequently built an apartment house on the site of the former theatre,
but nobody wanted to move into it because of the unhappy associations.
Amongst the first people to take one of the apartments were a newly married
young couple. When, a year later, their first child was born, the Emperor sent
a letter congratulating them on bringing new life to the site of so many
deaths. The newly weds were Dr and Mrs Sigmund Freud. It was thirty-three
years later that Freud wrote his long paper, centred on Hoffman's story,
'The Uncanny'.

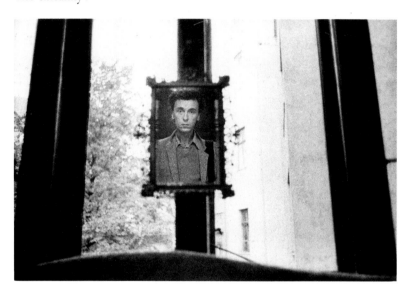

SIGMUND FREUD HAUS, VIENNA, BERGGASSE 19, 1981

"*OLYMPIA* CONSISTS OF SIX PANELS, ARRANGED AS TWO TRIPTYCHS.
I'll first say what the images, quite literally, show:

1. The head of the reclining nude in Manet's painting, *Olympia*.
2. A pool-side facility in Siesta Key, Florida. (The figure reflected in the mirror is me.)
3. James Stewart in Hitchcock's film, *Rear Window*. (Taken from the screen in a Paris cinema.)
4. Freud's study in 1938, from the book *Berggasse 19*.
5. The bouquet of flowers held by the maid in Manet's *Olympia*.
6. A friend photographed in a New York loft in the pose of Manet's *Olympia*.

"As you can see, these photographs are taken from a variety of different sorts of experiences: visiting a museum, looking at a book, going to the cinema, having a friend act a part for the camera, and so on. One of the things which interests me about photography is its ability to put very different things 'on the same level'. It seems to me that this is precisely one of the ways in which memory and fantasy work; for example, putting things which are 'in reality' small and insignificant on the same plane as things which, in worldly terms, are large and important. What interests me *most*, in fact, are the ways in which our experience of 'real life', the 'real world', is mediated by our memories and fantasies — this is what all my work, in one way or another, tries to deal with.

"This mixture of 'reality', memory, and fantasy — what Freud called 'psychical reality' — is made up not only of images, but of words too (with narrative playing an important part); so I also include textual elements in my work. The words in the first triptych narrate moments from a short story by the eighteenth-century German writer, Hoffman — 'The Sand-Man' (Freud discusses this story in his essay on 'The Uncanny'). The texts in the second triptych narrate moments from a case history by Freud and Breuer — 'Fräulein Anna O.'.

"What links these various elements, words and images, which are assembled here like so many fragmentary 'clues'?

"Both stories concern young women who are in the charge of a 'brilliant professor'; both women have names which begin with the letter 'O'. Let's put critical judgement on the shelf, and not protest, in the name of rationality, that this is no reason to associate the two women together. Let's allow the *irrational* processes, for example those found in dreams, to make the association *anyhow*. To refuse to do this would be to refuse to do the *work* this 'work' calls for — appealing to a 'dream-logic', rather than to 'common-sense'.

"In Hoffman's story, Olympia is a woman of wax; this reminds me of that other Olympia who is a woman of paint. Manet's Olympia reclines on a couch as a second woman brings her a bunch of flowers; this reminds me that Anna O., who was confined to her couch, complained that when her visitors brought her flowers she was unable to see the whole bouquet at once. By association, let the flowers which are being presented to Olympia represent those being shown to Anna O.; but 'Anna O.', here, must occupy the appropriate position from which to receive them, by adopting the posture of the woman in the painting.

"What else?

"Anna O. is under close medical supervision — in a sense, 'under surveillance'; under the careful professional scrutiny of a man just as 'Olympia' was when Manet painted her picture. In Hoffman's story, the young student who falls in love with Olympia rents a room overlooking hers and spies on her through a telescope. This reminds me of *Rear Window*, where a photographer spies on the apartment opposite him with the aid of a telephoto lens; so let James Stewart now play the part of this student, aiming his lens (through the 'window' of the frame) across the triptych towards Manet's model (herself already playing more than one role). The other 'Olympia' — Anna O. — in the New York loft, is in her turn already subject to the 'professional scrutiny' of a photographer. It is the position of *this* photographer that the viewer must take up in the act of looking, being given precisely the same point-of-view that *I* had when I looked through the lens.

"The viewer is further confirmed in the identity of 'photographer' by the image reflected in a mirror in the 'pool-side' photograph. The axis of the look directed by the 'photographer-viewer' into the mirror crosses, at 90 degrees, the axis of James Stewart's look towards Olympia. *This* man looks into a space which is both forbidden and impossible: the infatuated student looks into Olympia's private room; a filmed man looks at a painted woman. The photographer reflected in the mirror is also looking into a forbidden and impossible space. Although the *male* spectator in the gallery may be identified with the man reflected in the mirror, the reflected self-image is situated, contradictorily, in a place from which the man is excluded; the *female* spectator in the gallery may occupy this place but *not*, contradictorily, the identity 'male photographer'.

"In the first panel, the text tells how the student bursts into a room forbidden to him (the professor's office) to discover that the identity of

the object of his love is not what he had believed. The opening of the door in the second image relates this issue of identity to the fundamental question of *sexual* identity. The office into which we burst in the second tripytch is the site of those often violent struggles over identity which occur in psychoanalysis; the couch on which Olympia reclines now becomes the psychoanalytic couch — and we have now circled back, in the endless spiral of interpretation, to the point where Olympia and Anna O. are 'irrationally' merged together.

"I have said my work appeals to a 'dream-logic' rather than common-sense. Let me take the analogy between my work and the dream a little further. Freud remarked that the dream is meagre — 'laconic' — by comparison with its interpretation. Between what he calls the 'manifest content' of a dream (that which the patient reports) and the 'latent content' (the 'repressed' thoughts 'behind' the dream, which analysis seeks) there intervenes the irrational 'logic' of the 'dream-work'. Put another way: the path from what you remember of the dream (manifest content) to what you ultimately arrive at as the meanings of the dream (latent content) is neither logical nor direct. A common misconception of psychoanalysis sees interpretation as proceeding through reference to some sort of 'dictionary' of dream 'symbols'. As, of course, you yourself well know, nothing so simple is involved — interpretation is a complex process of association and comparison of one element of the dream with another, and with other thoughts and memories they may, by one means or another, evoke.

"The dream, Freud said, is neither the 'manifest' nor the 'latent' content; the dream, he insisted, *is* the dream-work. In explaining the way I composed *Olympia* I began with a literal account of those elements which are quite obviously *there* to be seen and read — by analogy, the 'manifest content'. I finally arrived at the concerns 'behind' the composition in questions of (sexual) identity and relations (here, the relation, 'looking/being looked at') — the 'latent content'. But I consider the *work* to be neither the one nor the other. If *Olympia* is considered only as 'manifest content' then we are left with nothing but a montage of minimally connected elements; if it is merely 'explained', reduced to its 'latent content', then we are left with questions which might be better dealt with in a theoretical essay, or political tract. But the work is neither an *object* to be consumed as 'spectacle', nor an *opinion* to be consumed as 'expression'. The work is not to be *consumed* at all, it is to be *produced* in the active process of looking, reading, comparing, interpreting.

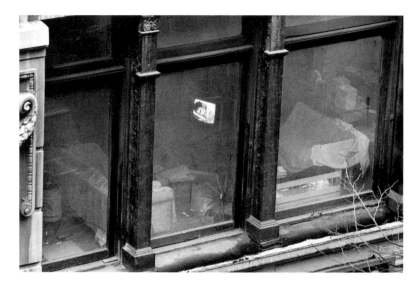

"Why make things so difficult for the viewer?

"We are a consumer-society, and it seems to me that art has become a passive 'spectator sport' to an extent unprecedented in history. I have always tried to work against this tendency by producing 'occasions for interpretation' rather than 'objects for consumption'. I believe that the ability to produce rather than consume meanings, and the ability to think *otherwise* — ways of thinking not encouraged by the imperative to commodity production, ways condemned as 'a waste of time' — is fundamental to the goal of a truly, rather than nominally, democratic society. I believe art is one of the few remaining areas of social activity where the attitude of critical engagement may still be encouraged — all the more reason then for art to engage with those issues which are *critical.*"

FROM A LETER TO A COLLECTOR

# C i n   C i t y

FIRST PART ONLY IN BLOCK 8, 1983

PRINCE WAS A hundred and fifty pounds lean, and the heavy overcoat couldn't keep the wind from reaching inside his rib-cage. He held the collar closed around his throat and picked his way up the filthy subway steps that would bring him out at Grand Street. His other hand gripped a shoe-box sized parcel to his chest.

Across town, the emigré Russian owner of the Mexicana Club was at his desk. He would stay that way until the cops had finished photographing him. The first rookie on the scene had reported: "Head wound. Sharp instrument. Maybe an ice-pick".

"Relative of yours?", Prince's smart-ass chief had asked, "They say he used to tell his lady-friends he was a prince".

At street-level the wind off the lakes ripped into him like a chain-saw. He leaned across it and made it into the apartment block. The lobby was a sticky jungle of tropical plants. Prince started to sweat. When he was a kid he'd been given a book about Mexico. He remembered a picture of a crystal skull, and a story about Aztec priests ripping open their victims with black glass knives. "Maybe an ice-pick". Prince knew better.

He'd taken off his overcoat in the elevator, the first time he'd let go of the item he'd found outside the Russian's office. The apartment on the thirty-first floor was as cool as the woman who had answered the door and who now sat facing him. She had a look which said she knew the price of everything, but wasn't buying. When he made his request she showed no surprise.

He knelt at her feet, untied the parcel, and took out the shoe. It was as black as night and shone like glass. It had one of those long vicious heels that have to be made of steel so they don't break. He held her ankle as he brought the shoe to her foot, which arched in response. Prince trembled. A black void opened up inside him and he was falling into it. The fit was perfect. "Get your things", he snapped, "You're under arrest".

HER STORY FITTED what he already knew. The Russian had made a pile in heroine, way back, then put it into legitimate businesses. He'd met her at a party. She was dealing cocaine on the side, a real *Snow Queen.* He'd seen the market possibilities. Before she knew it he'd involved her in a big, dirty, organisation. She wanted out. He wouldn't let her go. So she killed him. She hadn't meant to.

She had stirred, waking the detective, but now she was still, and he slid back into sleep. The Russian was trying to put the shoe back on her foot, but it wouldn't fit. The Chief said, "We'll have to amputate the toes". Prince looked down. Blood was oozing from her stocking. He woke in a panic. It was light. She was calling the airline. The evidence was in the incinerator.

Down in the lobby, the desk clerk silently perspired. The plants and the heat were taking over. Outside, a thin bitter wind lifted flurries of snow from the sidewalks and whirled them away. By midnight they would be high over the jungle.

THE BASIC PREMISE OF *HÔTEL LATÔNE* IS SIMPLE: A MAN AND A woman are watching TV in a hotel room. There's an estrangement between the two of them, of which they themselves are only dimly aware. Perhaps they put the feeling down to the room, and the boring film on TV. The basic theoretical premise is derived from a passage in Julia Kristeva's book, *La révolution du langage poétique*, where she says that it isn't so much the 'woman' who is denied access to representation under patriarchy, so much as the *reproductive* woman. Formally, the work is ordered to resist its own linearity. It works recursively. In a sense, you can never really get to the end, and if you do it's only to be sent back to the beginning. Have you had this experience in day dreaming? You know in advance where the fantasy is supposed to wind up, but the cost of deferring that *dénouement* — which, after all, is all that narrative does — is that you rarely succeed in arriving where you intended. Chains of associations take you continually away from your goal — or perhaps they know better than you do where you *really* want to go.

# Hôtel Latône

TWENTY PANELS, EACH 20 x 24 INCHES, 1983

IT IS TUESDAY

IN THE HOTEL

THEY WATCH TV

IN DECEMBER EVERYTHING IS FROZEN, PETRIFIED FOR ALL TIME

IN THAT EMPTY CABIN, IN THOSE SILENT WOODS

SILENT AND ALL-ENCOMPASSING WOODS WHICH PRESS AGAINST THE WINDOW-PANES

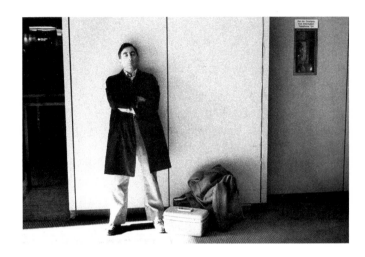

AS IN A FAIRY-TALE

HE TRAVELS. SLEEPING BEAUTY WILL WAKE HIM WITH A KISS

THEY ARE WATCHING TV

PHAEDRA TRAVELS. SHE FOLLOWS HIPPOLYTUS TO TROEZEN
WHERE SHE BUILDS THE TEMPLE OF PEEPING APHRODITE
TO OVERLOOK THE GYMNASIUM, AND WATCHES UNOBSERVED WHILE HE EXERCISES.
JUST ABOVE THE LINE OF THE CRACK THERE IS A TRIANGLE OF PUBIC CURLS
WITH, AT THE APEX, THE REMNANTS OF MALE GENITALS

THE EFFORT OF HOLDING THE CAMERA TO HER EYE IN THE NOON HEAT
IS CAUSING PERSPIRATION TO RUN INTO THE HOLLOW OF THE EYE-PIECE

THE SHADOWS ARE LENGTHENING,
THE REFLECTION OF THE DESCENDING SUN GLARES FROM THE BAY.
FROM THE BALCONY OF THE HOTEL, BEYOND THE CANE ROOF OF THE TERRACE BELOW,
A BUS IS SEEN LYING BY THE SHORE LIKE A FALLEN COLUMN.
IT IS SMOOTH TO HIS TOUCH, ABOVE THE LINE OF THE CRACK IS A DELTA OF CURLS

THE STORY IS BARELY HOLDING THEIR ATTENTION

SHE CAN NO LONGER CONTAIN HER IMPATIENCE.
SHE READS OUT LOUD THE CAPTION TO A PICTURE WHICH HANGS ON THE WALL:
"LATONE, BETWEEN HER TWO CHILDREN APOLLO AND DIANE,
DEMANDING VENGEANCE FROM JUPITER UPON THE INSOLENCE OF THE PEASANTS OF LYCIA,
WHO ARE CHANGED INTO FROGS"

 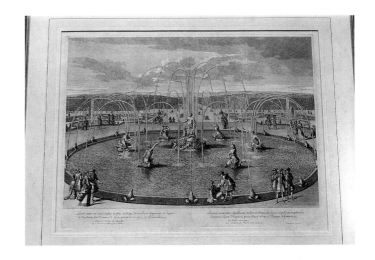

HE HAD NOT PREVIOUSLY NOTICED THE IMAGE.
IT REMINDS HIM OF A PASSAGE FROM SADE
WHERE THE HEROINE IS POSED ON A PEDESTAL SURROUNDED BY A MOAT.
HER ADMIRER MAY CAUSE THE PEDESTAL TO TURN BY MEANS OF A REMOTE CONTROL:
HE MAY LOOK, BUT HAS NO MEANS OF APPROACHING HER

''HIS HAND, HEAVY AS A ROCK, CANNOT BE BROUGHT TO ENCIRCLE HER WAIST;
HIS GARRULOUS LIPS WILL NEVER REACH HERS;
AND IF IN AN ADVENTUROUS MOMENT HE HOLDS HER IN ANY WAY,
IT WILL ONLY BE TO SEE HER CHARM VANISH AND HIS DESIRE QUICKLY FADE AWAY.
MORE UNPITYING THAN A WALL IS THE SPELL THAT HAS BEEN CAST.''

 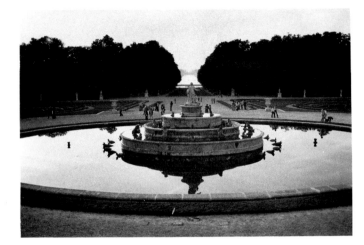

WHILE HE READS
SHE TURNS A SMALL VASE OF FLOWERS, SEEKING A VIEW WHICH WILL SATISFY HER.
TWILIGHT IS APPROACHING.
SURROUNDED BY AIMLESS STROLLERS, FLANKED BY HER CHILDREN,
SHE TURNS TO FACE THE FAILING LIGHT BETWEEN THE SOMBRE TREES

SHE DOES NOT TURN:
IF SHE LOOKED BACK SHE WOULD BE RECLAIMED,
TURNED TO STONE.
SURROUNDED BY AIMLESS STROLLERS SHE LEAVES THE SOMBRE AVENUE AND EXITS ALONE.
*END*

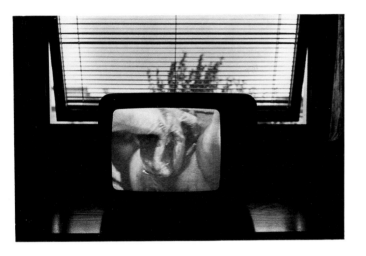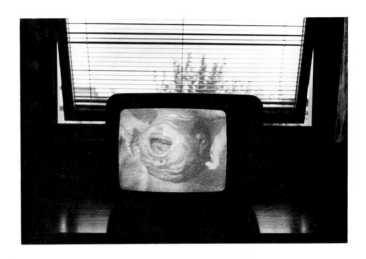

HE IS SPENDING AN EVENING WATCHING TV                IT IS TUESDAY

AT SOME POINT IN MY LIFE, I DON'T REMEMBER WHEN, I BECAME diagephobic. Today, I can't bear to read a novel. Nor, with very few exceptions, can I watch a fiction film — unless it's liberally laced with excessive spectacle, otherwise I invariably find the locations more interesting than the actors. I would probably literally suffocate if I were to be incarcerated in a theatre for the duration of a play. Yesterday, I saw two stills from *We All Loved Each Other Too Well*, which are the only images to be used as publicity outside the cinema which is showing the film. They are accompanied by an enlarged copy of a favourable review. The images are well chosen, and it seems to me they tell me all I need to know about the film. To sit in the cinema for two hours — the length of the narrative — seems redundant in the face of this most economical of condensations. The text confirms my initial reading of the images. What the film 'itself' will offer me are *performances* of actors — *theatre*. I shall once again watch actors walk down streets, cross rooms, open and close doors, react in close-up, lift cups, glasses, and morsels of food, to their mouths, . . . and so on. I take in a lot of films this way, in the form of synopses and stills, and also in the form of film theory, with its photograms and fragments of significant dialogue. This explains why I enjoy Godard, but not why I like Hitchcock.

SOMEONE, WHOSE AUTHORITY I RESPECT, BUT WHOSE NAME I'VE forgotten, told me that the practice of giving art-history lectures in front of pairs of projected images originated with Heinrich Wölflin. Wölflin, however, my authority informed me, didn't make comparisons between the images, he didn't even refer to them. The images served merely as a 'backdrop', a theatrical device. Not the theatre of realist drama — where the appropriate word would be not 'backdrop' but 'set', a naturalistic modelling of the space occupied by the body of an actor — not realist drama, but ballet, or music-hall, where the backdrop serves to say, 'picture this dance, or this song, or this monologue, as issuing from a city street, or from beside a lake'. Or again, we might think of those political speeches which are delivered against a backdrop of portraits of leaders. So we not only think *with* images, and *about* images, we also think *against* images, *alongside* images. So picture this as issuing from an imaginary space which has been furnished with a number of images from the film *Vertigo*. I'm not talking about the film 'as such' — if such an entity could be said to exist outside the brute material fact of the reels of celluloid — so it doesn't matter too much if you haven't seen it. The images don't serve to specify the particular, they are intended to represent the general.

I THINK OF THE GALLERY AS THE NEGATIVE OF THE CINEMA. THE room in which the film is shown is in darkness, the room in which my work is shown is light. In the cinema you are still and the images move, in the gallery the images are still and it is you who move. In the cinema you cannot control the sequence or duration of your reception of the images, in the gallery you can. I believe it's through attention to such *differences* between conditions of spectatorship that the work on the walls can release the exhibition space from the *image*-centred nostalgia of the 'picture-gallery' — something which always has the musty odour of ducal palaces about it — and allow it to enter the general arena of sites of contemporary experience; experience which is characterised not so much by the *image*, but rather by the continual *exchange* of one image for another.

# The Bridge

**EACH PANEL 30 INCHES IN HEIGHT, 1984**

# THE BRIDGE

'i' vegno per menarvi a l'altra riva'
*I come to carry you to the other shore*
Dante Alighieri *Inferno* Canto III. 87

In everyday language it is common to find the word 'bridge' used to metaphorically express such otherwise abstract notions as 'exchange' between two parties and 'transition' from one state to another. In the literature of psychoanalysis the image of the bridge is often cited as figuring in dreams and phantasies as more specifically representing the penis which joins the parents in sexual intercourse and the transitions of birth and death. Water, with which bridges are readily associated, does of course itself have both actual and symbolic associations with sexual intercourse, birth and death. Further, in the history of Western representations, literary and visual, water is strongly associated with the woman, and it would not strain scholarship too far to argue an (admittedly less pronounced) association of the bridge with the man.

The work shown here has a particular bridge – the Golden Gate Bridge – as its 'jumping-off point'. More appositely, switching metaphors, the work is born from a watery theatrical scene for which this bridge serves as proscenium arch – that moment in Hitchock's *Vertigo* when Madeleine (Kim Novak) throws herself into San Francisco Bay and is rescued by the detective, Scottie (James Stewart).

When I first read a short essay by Freud called, 'A Special Type of Choice of Object Made by Men', I was struck by the similarities between the syndrome of male desire Freud describes and the pattern of behaviour Scottie exhibits in Hitchock's film: The first condition determining the choice of love-object by the type of man discussed in Freud's essay is that the woman should be already attached to some other man – husband, fiancé, or friend; in the film, Scottie falls in love with the woman he is hired to investigate – the wife of an old college friend. The second precondition is that the woman should be seen to be of bad repute sexually; Madeleine, the college-friend's wife, suffers from a fixated identification with a forbear whose illicit love-affair, and illegitmate child, brought her to tragic ruin. The type of man described by Freud is, "invariably moved to rescue the object of his love", and prominent amongst the rescue phantasies of such men is the phantasy of rescue from water; Scottie rescues Madeleine from the Bay. Finally, Freud observes, "The lives of men of this type are characterised by a repetition of passionate attachments of this sort . . . each an exact replica of the other", and he remarks that it is always the same physical type which is chosen; following Madeleine's death, Scottie becomes obsessed by Judy, who physically resembles Madeleine and who he sets about 'remaking' into an exact replica of Madeleine.

Behind the pattern of repetitious behaviour he describes, Freud identifies a primary scenario of male Oedipal desire for the mother – already attached to the father, her sexual relations with whom bring her into ill-repute in the eyes of the little rival for her love. The ubiquitous phantasy of rescue from water represents a conflation of 'rescue' with 'birth', just as he was, at birth, 'fished from the waters' and given life, so will he now return this gift to his mother in a reciprocal act of recovery from water. Finally, the adult man's love-attachments form an endless series of similar types for the simple reason that, as mother-surrogates, they can never match the irreducibly unique qualities of the original.

As I have already remarked, the history of Western representation is flooded with watery images of women – from the birth of Venus to the Death of Ophelia, with countless bathing scenes between. If, in the history of representations under patriarchy, water is seen as woman's natural element, it is most likely because, in male phantasy, the woman's body is itself *liquid*: in its lactation: in its menstruation, matching the movement of the tides; in its wetness in love; in its (socially sanctioned) capacity for tears; and so on. By corresponding token, the over-arching (over-*bearing*) patriarchal principle readily finds figuration in the image of the bridge. It is by the way of such metaphorical tableaux –*allegories* – that the social order is imprinted in the unconscious. In the way we repeat or recast such tableaux, therefore, there is always more at issue than 'mere metaphor'.

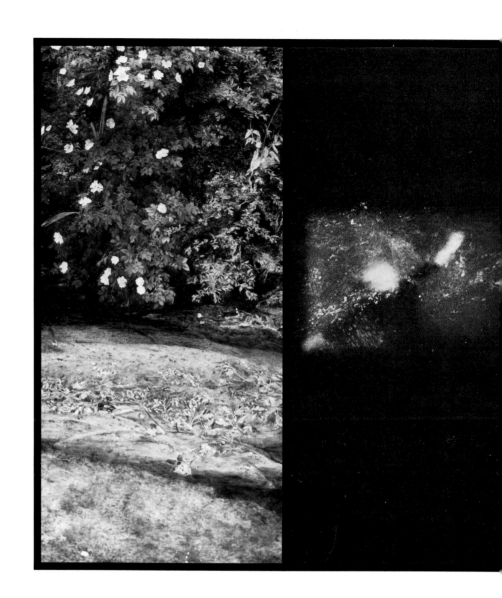

SILENTLY
VIOLENTLY
THE WATERS BREAK                                    ACROSS THE P
AROUND THE EMERGING FORM              UPON THE GLASS WA
OF A WOMAN                                              OF THE CORRI
HER TANNED FLANKS                             I TOOK MY LAST C
STREAMING WATER                                  FROM THE RO
SHE FOLDS A TOWEL                        AND CLOSED THE DO
AROUND HER NEW-BORN BODY                          LEAV
LONG SHADOWS OF PALMS                             CALIFOR

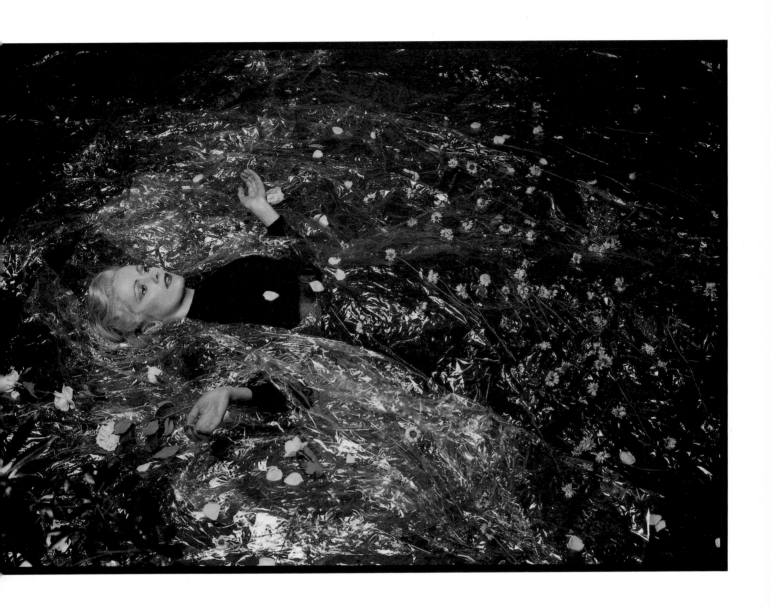

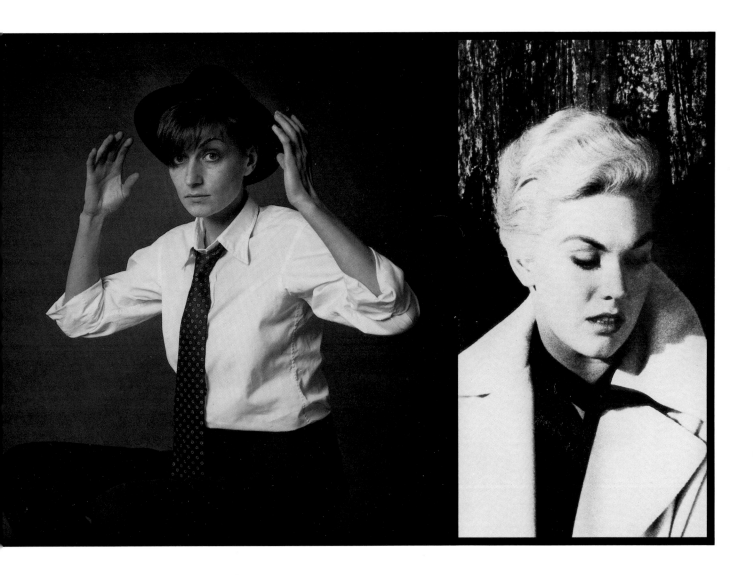

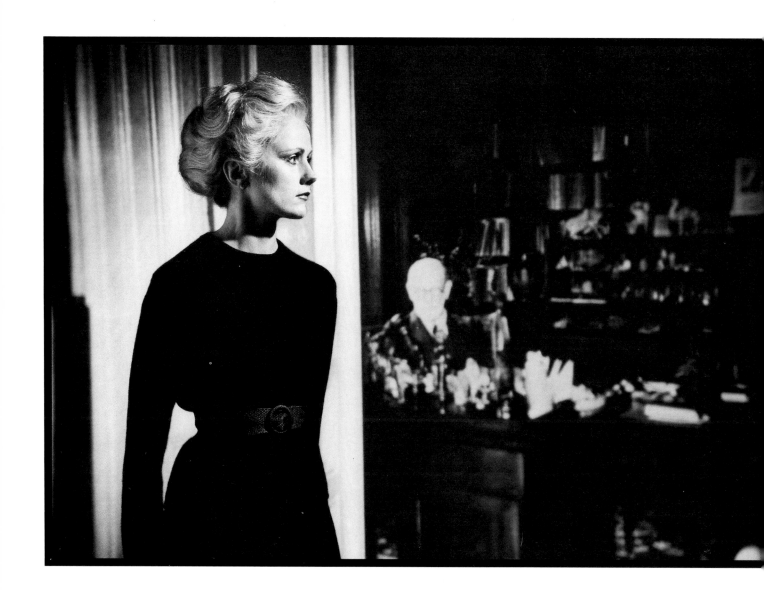

| | |
|---|---|
| VE SEEN | FROM BURNING |
| T OBSERVED | IN YOUR DREAM THOUGHTS |
| ARNED YOU NOT TO PLAY WITH FIRE | YOU ONLY FIND |
| THIS LIES A FOLK-BELIEF | THE JEWEL-CASE |
| LD WHO DOES SO WETS ITS BED | GETTING WET |
| NG OF FIRE | FIRE IS CONTARY TO WATER |
| DREAM | AS METAPHOR |
| OTHER WANTS | IT STANDS FOR LOVE |
| E THE JEWEL-CASE | WHICH MAKES YOU WET |

HIDING

INSIDE

HE WATCHES

WHILE SHE STARES

AT THE PORTRAIT OF A WOMAN

NOTING ATTRIBUTES BY WHICH

THEY RESEMBLE EACH OTHER

PUZZLE-PIECES

HAIR

BROOCH

THE FLOWERS

SHE WILL SCATTER ON THE BLACK WATER

WHERE HE WILL DESCEND LIKE ORPHEUS

INTO THE DARKNESS BENEATH THE BRIDGE

WHERE SHE WILL FLOAT LIKE OPHELIA

AMONGST THE FLOWERS

WHERE HE SEEKS A FACE GLIMPSED

BELOW THE SURFACE OF THE WATER

BELIEVING IT BELONGS TO SOMEONE

OTHER THAN HIMSELF

KNOWING SHE IS WATCHED

SHE IS STILL

TO RECEIVE

THE LOOK

HE IS

HIDING

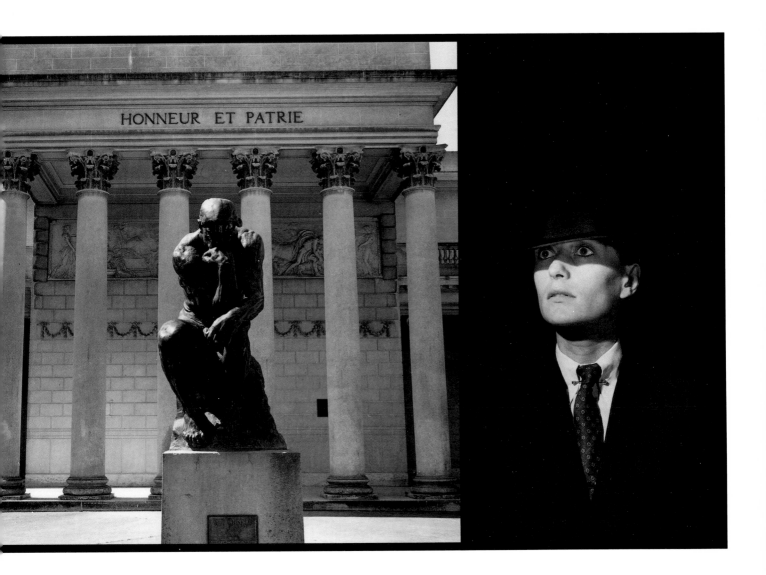

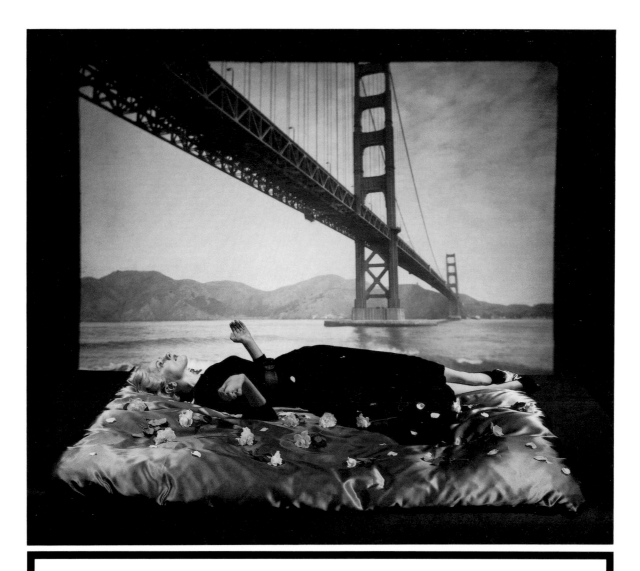

I'VEGNO PER MENARVI A L'ALTRA RIVA

WHEN I WENT TO ART SCHOOL I WAS TAUGHT TO APPRECIATE the 'formal' aspects of an image — such things as the relative dispositions of main elements, contrasts of size and shape, line and tonality, and so on. Today I'm interested in a different understanding of form; for example, in this work I'm interested in the formal structures Freud described in terms of the 'dream-work'. This image provides an example of 'condensation': the model has adopted the pose of Millais' *Ophelia*; her clothing, make-up, and wig, however, are styled on the basis of movie-stills from Hitchcock's *Vertigo* — pictures of Kim Novak in the part of 'Madeleine'; the convention of using cellophane to represent water is derived from fashion-photography practices of the 1930s — particularly from the work of Cecil Beaton. Incidentally, I can't tell you how difficult it was to find the cellophane for this shot — everyone uses polythene these days.

A PROBLEM FACING ME WHEN I WRITE THESE SHORT TEXTS IS TO cram as much as possible into the small space I've allowed myself. I've already talked about the way photographs may contain banal and apparently insignificant elements which although they may receive little or no conscious attention may nevertheless activate pre-conscious and/or unconscious chains of associations. A text, needless to say, may have a similar capacity, and I sometimes try to 'program in' certain 'subliminal' references. Here, for example, I've split the type into two columns, with the type 'ranged left' in one and 'ranged right' in the other. First of all this encourages the tendency to read lines horizontally across both columns, as well as vertically; so here you can begin, "Silently, violently", and so on, or, "Silently lie" — the word 'lie', of course, already offers a double meaning (Madeleine's charades at the beginning of *Vertigo*, staged for Scottie, are 'silent lies'). The way the lines are broken also gives a graphic pattern which can allude to the 'ripple' effect on the surface of water — so the 'watery' imagery is carried into the very appearance of the type. Now the text begins by reading most literally as an account of a woman *emerging* from water — so there's a counterbalance, a 'reversal into the opposite', of the photographic reference to the *submerging* Ophelia. We're all familiar with Botticelli's image of the *Birth of Venus* — so I'm hoping to activate this pre-conscious image, or some other similar image, and whatever may attach itself to it. By using the phrase, "the waters break", and emphasising it by giving it a line to itself, I hope to evoke the idea of the 'breaking of the waters' in childbirth. It's for this reason that I use the image of the folding of the towel (blanket) around the "new-born body" — an expression chosen for its proximity to the cliché, "new-born baby". So we have a number of images here which connect with representations of women, predominantly by men. The figure of the man here is inscribed in the line, "I took my last case" — a pun in which 'case' is both the piece of luggage in the literal narrative and also the detective's last case — Madeleine is Scottie's last case. The text is also written to include images of division, separation and loss. I'd stress, again, that I'm *not* saying that any or all of this is the 'true meaning'. I'm simply describing the sorts of decision-making processes I go through when I'm making the work. What results may be read very differently, but with no less validity, by someone else.

FREUD REFERRED TO WOMAN'S SEXUALITY AS A 'DARK continent'. For the man, woman's sexuality is an *enigma*, a mystery which may arouse an obsessive and insatiable curiosity. In the cinema, the projection of this perception of the woman has given us the figure of the 'mysterious lady', whose frequent association with criminality is the projection of the anxiety, even fear, which her sexuality may arouse in men. The obsessional man, the one who is driven to *investigate* the enigma of the woman, is often represented by the figure of the detective; in this way, obsessive male voyeuristic curiosity is given an alibi, the mystery of the woman may then be interrogated without impropriety: 'It's all right, Madam, I'm a detective.'

In the earlier scenes of *Vertigo* we see the detective hiding himself in order to spy on Madeleine, later in the film there are scenes of interrogation in which we see the *excess* in Scottie's demands, the impossibility of their being met in the way he *desires*. *We* see, for of course another look crosses the axis of the desperately interrogative look which Scottie directs towards Madeleine — our own voyeuristic and interrogative gaze: 'What will they do next?' In the gap which separates Scottie and Madeleine here I have reduplicated the figure of the detective to receive and acknowledge this gaze by *returning* it. But our look is returned by a *composite* figure which partakes as much of Madeleine as of Scottie. This figure is caught, literally and figuratively, in the moment of *arrest*, 'Hands up!' But it is the detective here who is arrested, unless we interpret the gesture as echoing that of Ophelia, in which case we may identify the figure as Madeleine, but then it is the clothing which must be a masquerade, unless after all the posture is an imposture. It is undecidable. The identity is 'slippery'; and if the identity receiving our look is so uncertain, then perhaps the same uncertainty may now have invaded the position from which *our* look is given. It is perhaps a relief to return to witness the self-possession with which Scottie challenges Madeleine, and the unequivocal passivity with which she receives *his self*-assertion. But whose side are we *really* on?

# Portia

HEIGHT 20 INCHES, 1984

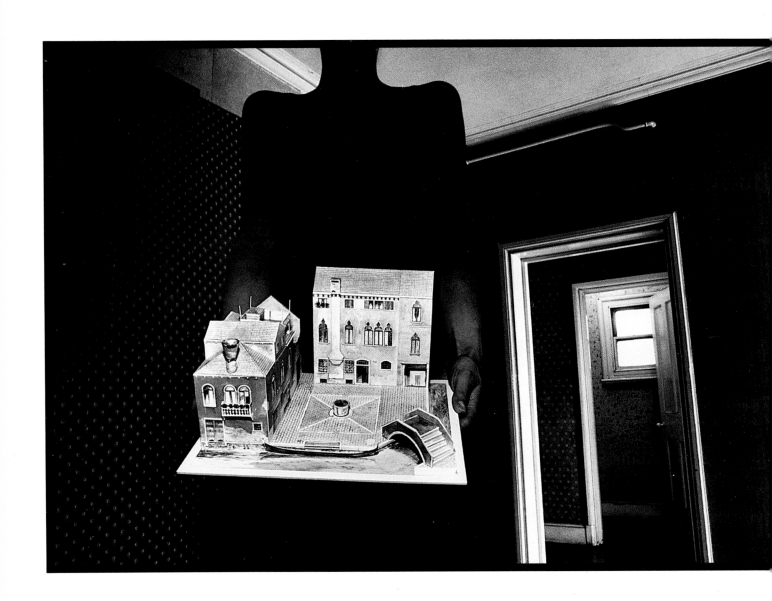

A PATCH OF LIGHT
ON STAGE.
SHE, MOTIONLESS.
HE, REACHING OUT.
BETWEEN THEM,
THREE BOXES.
ONE HOLDS
HER IMAGE.
'THY PALENESS
MOVES ME MORE THAN
ELOQUENCE'.
THE SPEECH
DIES
INTO SILENCE.
THE MORETTA,
WORN ONLY BY
WOMEN,
IS HELD IN PLACE
BY A BUTTON
GRIPPED IN
THE MOUTH.
A PATCH OF DARKNESS.

I WAS TOLD THAT THE ORGANISERS OF THE EXHIBITION WANTED to show *Gradiva*, *Olympia*, and a 'new work'. I thought it would be appropriate if these two fictional women were to be joined by a third who, like them, had also appeared in Freud. I decided on Portia, from Freud's short paper, 'The Theme of the Three Caskets'. If you're familiar with Shakespeare's *The Merchant of Venice*, then you'll remember the scene in which Portia's suitors try to guess which of the three caskets contains her portrait — Portia being bound by her father to accept the man who chooses correctly. One of the caskets is made of gold, another of silver, the third is of lead, and each suitor gives a speech in praise of the metal of his choice. If you remember this then you'll also remember that the scene has a happy ending, with Portia's preference — Bassanio — guessing correctly that her image is in the box of lead. Freud links this scene from Shakespeare to a host of other literary items, myths, fairy-stories, and so on, with which it shares similarities — for example, the Judgement of Paris. He argues that what is at issue in all these scenes in which a man chooses between three women is a gesture of command over what cannot be commanded — death. A double reversal is enacted in which death — that which is *feared* and which *chooses* — is represented by a woman, she who is *desired* and who is *chosen*. The remaining two women in the stories, incidentally, represent the other most important women in the man's life: the mother, and the wife.

ONE OF THE REASONS FOR *MY* CHOICE OF PORTIA WAS THAT I'd been invited to give a talk in Venice. I hadn't been there before, and I thought I'd use the opportunity to research the work and make some photographs for it. I hadn't foreseen that any photograph made in Venice, and which is able to *say* 'Venice', also seems unavoidably to murmur 'picture post-card'. I came across the solution to my problem in a small book-shop where I found some of those architectural models which you have to construct out of thin card. One of the models was of a square in Venice; not any particular square, it combined typical features from a variety of squares — perfectly in accordance with the principle of 'condensation' as described by Freud in *The Interpretation of Dreams*. The shot with the model was made in London. The other image here — the masked woman on the right — is a detail from an eighteenth-century painting by Pietro Longhi: one is in the Ca' Rezzonico, in Venice; the other is in the National Gallery, London. I took this picture in the National Gallery. The woman is in the background of a very small painting, so the degree of enlargement is enormous. I first learned about the mask she's wearing — the Moretta — from a mask maker in Venice. It was one of only two masks traditionally worn at carnival time, it was black, and it was worn only by women. The Moretta was held in position on the face by means of a button gripped by the teeth — so that in order to speak, the woman had to unmask, to quite literally 'reveal herself'. The other mask, incidentally, is called the Bauta. The Bauta was white, and held in place in a conventional way — with tapes tied behind the head. It could be worn by either sex, and you can see it in the same Longhi painting, *The Rhinocerous*, being worn by a man.

ONE OF THE REASONS I DROPPED PAINTING, AND TURNED TO photography and writing, was to establish a link between the work on the gallery walls and the everyday environment beyond those walls. The use of photo-text was a way of establishing a continuity of languages between the cultured tones of 'high art' and the vernacular of the 'mass media'. I see the culmination of that initiative, at least my own clearest statement of it, in the 1976 *Possession* poster project. The posters went up in the streets of Newcastle, and on the interior walls of the Hayward Gallery (for the 1977 Hayward Annual) without any concession whatsoever to the gallery setting. The museum was treated as nothing more than an extension of the space of the street. Modernism's 'separatist politics' had turned the museum into a sort of church, a place of worship of saintly relics and a *sanctuary* from everyday life. For me, that poster work was a symbolic 'ground clearing', preparatory to rebuilding. In real terms, of course, my metaphor is wrong. As someone else said (I think it was Gayatri Spivak), such cultural-political work is more like tidying your room — it never *stays* tidy, and the work has to be continually repeated. For me, today, the 'room tidying' is mainly what I do when I teach, and write more or less polemical articles. This sort of work, like the poster work, involves an effort to *simplify* in the interests of communicational clarity, and it also involves a very great deal of repetition. For me, now, the gallery has become the place where I can make a more complex text, a text which is intimately bound up with my theoretical work, but which is freed from the imperative to *teach*.

The project of bringing the museum back into contact with its social and political environment is very differently conceived in subsequent work. The work I made *In Grenoble*, for example, is a re-reading of a painting by Claude by way of contemporary theoretical and political concerns, which in turn are expressed in terms of the contemporary environment of that painting — the streets of Grenoble. At the same time, obviously, this work is a long way from the populist project of taking art, *literally*, 'onto the streets' (if I were to return to that project now I would certainly see it in a very different way, not least because of the new information technologies which have taken us very far indeed from the *Agitreklama*, 'factography', days of Rodchenko and Mayakovsky). To take another example, the work which quoted *Vertigo* stitches together, and overlays, a number of references to painting, film, and photography to construct its *mise-en-scène* of male desire. It connects the museum as a site of representations, a discursive institution, to other such sites contemporary with it in order to interrogate one of the dominant thematic products of such institutions.

THE PIECE I'M WORKING ON AT THE MOMENT CONTINUES THIS *re*-viewing of art through a prism of contemporary concerns. The particular *pre*-text in this case is Edward Hopper's painting, *Office at Night.* When I was a very small child I was given a very large illustrated book called, as I remember, *The Wonder of Life.* It was my favourite book. Retrospectively, I can identify it as a book of popular science, and certainly not a children's book. One of the images I remember particularly well is a drawing of a businessman walking down a leafy suburban street of tudor-fronted houses. He's clearly identified as a 'city gent' by his bowler, pin-striped suit and furled umbrella. The sun is shining. We're looking at this man from a low viewpoint because we're half-way down into a ditch which parallels the pavement the man is walking along. He seems unaware of this pit at his feet, and his steps are perilously close to the edge. Crouching in the ditch is a horde of brutal and threatening Neanderthal men, dressed in animal skins and carrying huge clubs. A piece of knowledge I remember from childhood, derived no doubt from a caption to this image, is that the Neanderthals are waiting for nightfall, when they will overturn this scene of peacefully ordered normality. I can recall the mixture of *complete* incomprehension and *total* acceptance with which, as a child, I regarded this image. Today I can only assume that the illustration belonged to a chapter on psychology, and was an earnest, albeit erroneous, attempt to communicate a picture of the relation of conscious to unconscious mind by way of a distinction between the 'baser' instincts and reason. I recently remembered this diagram of vulgar Freudianism while I was talking to a friend about *Office at Night.* In a more recent (Lacanian) terminology, we could characterise Hopper's picture as a *mise-en-scène* of the conflict of 'Desire' and the 'Law'.

*OFFICE AT NIGHT* MAY BE READ AS AN EXPRESSION OF THE *general* political problem of the organisation of Desire within the Law, and in terms of the *particular* problem of the organisation of sexuality within capitalism — the organisation of sexuality *for* capitalism. Patriarchy has traditionally consigned women to supportive roles in the running of the economy, subject to the authority of men. The 'secretary/boss' couple in Hopper's painting is at once a picture of a particular, albeit fictional, couple and an emblem, 'iconogram', serving to metonymically represent all such couples — all such links in the chains of organisation of the (re)production of wealth. Such coupling for reproduction must of course contain its sexual imperative. The family functions to contain, restrain, this imperative in so far as it is directed towards the reproduction of subjects for the workplace. The erotic supplement to the biological imperative cannot however be contained in the family. It spills into the place of work, where it threatens to subvert the orders of rationalised production. The painting, clearly, may represent such a moment of potential erotic disruption in appealing to such preconstructed meanings, items of the popular pre-conscious, as are filed under, for example, 'working late at the office'. At the same time the painting stabilises the situation by providing a moral solution to the problem of the unruly and dangerous supplement. That the morality is patriarchal goes without saying.

STABILITY IS MADE *PHYSICALLY* MANIFEST IN THE MASSIVE FORMAL stasis of this painting by a man who admired Courbet. Within a setting of firmly interlocking rectangles the main compositional device is a triangle, its base the bottom edge of the frame and its apex in the head of the woman, making her the focal point of the image. From her head, our gaze is allowed unrestricted movement down the full length of her body. This body is twisted, impossibly, so that both breasts and buttocks are turned towards us. The body is ostensibly clad in a modest dress, but a dress which clings and stretches like a costume of latex rubber. An ambivalence similarly inhabits the woman's gaze. Her eyes may be downcast, conventionally connoting modesty, or she may be directing a seductive or predatory look towards the man at the desk. This man does not return her look, his gaze is upon the strangely rigid sheet of paper in his hand. I'm reminded of Perseus, gazing into the shield which is about to reflect the image of the Gorgon. Clearly, if any impropriety were to take place here, then it would not be *his* fault. The painting therefore offers the heterosexual male viewer, by identification with the man in the image (in the imaginary) the exciting promise of a forbidden satisfaction *without blame attached*. The elaborately constructed alibi pivots on a disavowal of voyeurism: 'I (male spectator) know very well that I am looking at the body of this woman, but nevertheless I (imaged man) am not.' The painting offers itself as evidence in his defence, like a photograph presented in a court of law.

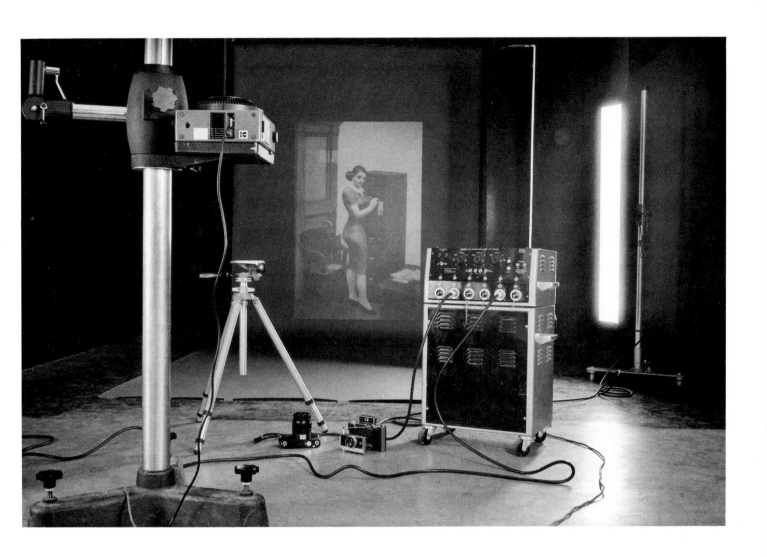

HOPPER SPENT A YEAR IN PARIS IN 1906 AND EXHIBITED IN the Armory Show of 1913, but he never had any truck with Modernism. Today, history has moved around his work and effectively changed its 'valency' from aesthetic conservative to proto-postmodernist. There is much in Hopper's work which clearly derives from the cinema and from photography, and throughout much of his life he was directly involved in the production of vernacular imagery in his work as an illustrator. In a recent book on Hopper, Gail Levin observes that the office equipment and furnishings seen in the 1940 painting, *Office at Night*, are derived from his office illustrations of the 1910 period, albeit the dress worn by the woman in this picture clearly belongs to the same period as the painting. In the photographs I've just started shooting 'around' this image, my model wears a 1940s business suit — as a sort of 'tacking stitch' loosely pinning the images to the period of the painting — but I've made no other gesture towards a 1940s feel. History has moved around my own work, changing at least one of its meanings. When I began using photo-text it was in the interests of a 'zero degree' of style, an 'absence' of style. Today, such work constitutes a distinct genre, and an item in the available repertoire of stylistic conventions. For this particular work I would like to vary the genre a little. To emphasise the reference to the social order, I'm thinking of replacing the printed word component with the 'Isotype'.

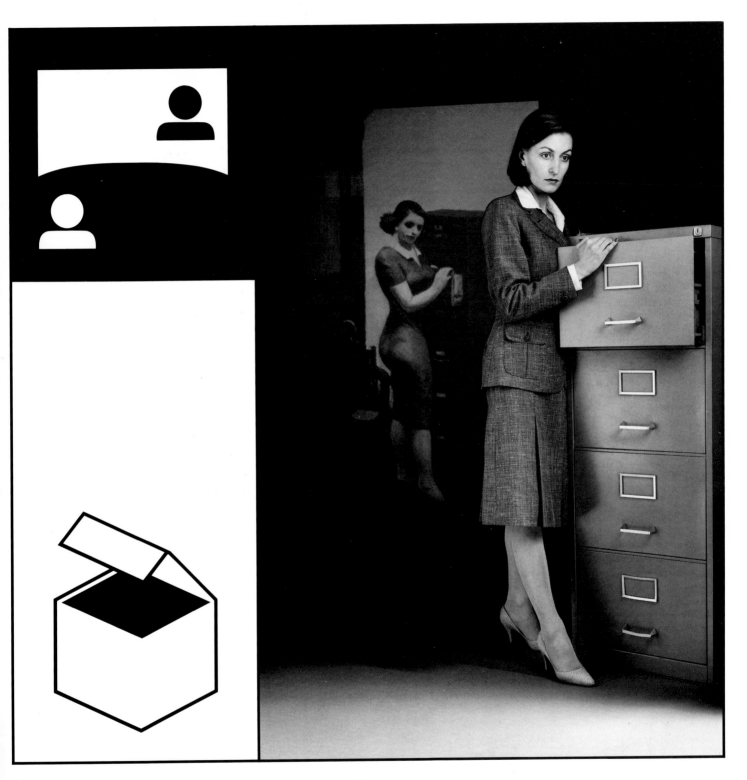

PREPARATORY WORK FOR OFFICE AT NIGHT, 72 INCHES HIGH, 1985–86

THOSE UBIQUITOUS PICTOGRAMS WE SEE — FOR EXAMPLE, offering us directions in bus-stations and airports — have an interesting history. They derive from the 'Isotype' movement, which began in the 1920s under Otto Neurath. Neurath was a member of the Vienna Circle of logical positivist philosophers. One of the ambitions of the Vienna Circle was to develop an unambiguous international language for science. Neurath, however, was also very interested in politics, in sociology, and in education. His ambition for the Isotype — which is an acronym for International System of Typographic Picture Education — was that it would develop into an unambivalent international picture language for everyday use. It's interesting to think of this search for the unambiguous image taking place in Vienna at the same time as Freud's researches into the irresolvable ambivalences of the psychic processes. With the onset of Nazism both Neurath and Freud took refuge in England. There's an appropriate coda to this. The Isotype archive is currently lodged at Reading University, which is unusual in having a Department of Typography and Graphic Communication. One of the legacies of the Isotype movement is a problem which, I've been told, successive generations of students at Reading have attempted to solve. It's this: design an Isotype, a pictogram, which says neither 'man' nor 'woman', but simply *person*.